IMAGES
of America

PRUITT-IGOE

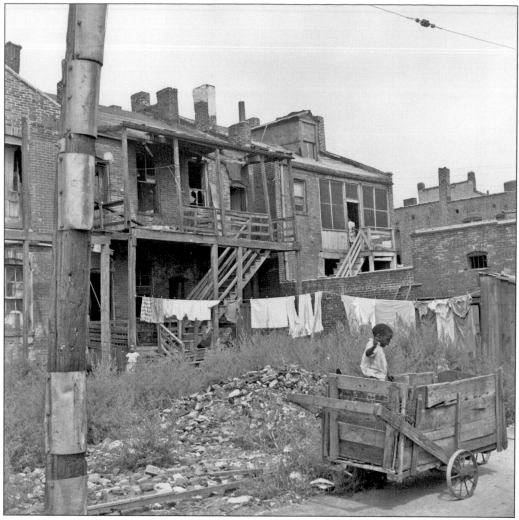

Pruitt-Igoe was carved out of the DeSoto-Carr neighborhood. This photograph was taken around the time Pruitt was opening in 1954. The ubiquitous pushcarts would show up again years later in the last days of Pruitt-Igoe itself. (SHS.)

ON THE COVER: Children are seen here playing in one of the neighborhood playgrounds that used to be in the Pruitt-Igoe complex. (MHS.)

IMAGES
of America

PRUITT-IGOE

Bob Hansman

ARCADIA
PUBLISHING

Published by Arcadia Publishing
Charleston, South Carolina

Printed in the United States of America

Library of Congress Control Number: 2016962530

For all general information, please contact Arcadia Publishing:
Telephone 843-853-2070
Fax 843-853-0044
E-mail sales@arcadiapublishing.com
For customer service and orders:
Toll-Free 1-888-313-2665

Visit us on the Internet at www.arcadiapublishing.com

Dedicated to and in memory of
Rev. Joel Kelly Davis Sr.
(April 5, 1915–May 17, 2016)
Grace Baptist Church, "The Pearl of Cass Avenue"

CONTENTS

Acknowledgments 6

Introduction 7

1. A Pleasant Surprise Is in Store for the Tenants 9

2. Our Life Is What Our Thoughts Make It 41

3. Not Too Costly a Mistake 77

4. Searching for Kim Gaines 89

5 A Little Bit of Explosives with a Lot of Gravity 99

6. A Perfect Vertical Severance 107

7. Behold the Tabernacle of God with Men 119

ACKNOWLEDGMENTS

Thank you to Tim Pemberton; Mike Meiners, *St. Louis Post-Dispatch*; Rev. Jonathan Davis; Felicia Davis; Bernadette Davis Jones; Michael Allen; Rena Schergen, archivist, Archdiocese of St. Louis; Lois Conley, Griot Museum of Black History; Sister Charlene Moore; Charles E. Brown, St. Louis Mercantile Library; Tom Thompson; Penelope "Penny" Smith; Billie Johnson; Elise Novak; Nancy McIlvaney, photograph archivist, The State Historical Society of Missouri; Dick Rosenberger; Percy Green; Miguel and Carla Alexander, Tillie's Corner Historical Project; Brian Woodman; Robert Green, Frederick A. Douglass Museum of African-American Vernacular Images; Miranda Rectenwald, curator of Local History, Archives & Special Collections, Washington University Libraries; Sonya Rooney, University Archives, Special Collections, Washington University Libraries; Calvin Riley, George B. Vashon African Research Museum; the *St. Louis Argus*; Frankie Muse Freeman; Amanda Claunch, MHS Photo Archives, Missouri Historical Society, St. Louis; the *St. Louis Evening Whirl*; Renita Waters; Ida Mobley; Gloria Ross; Louis Kruger, St. Louis Public Schools; Jack and Odester Saunders; Andy Raimist; Brother Earl; Lillie Glenn, St. Louis Housing Authority; Chris King, *St. Louis American*; Chris Krehmeyer, Beyond Housing; Aaron J. and Mary L. Witherspoon; Marilyn Shnider, Baltimore Sun Media Group; William Kiefer Jr.; Jo Ellen Rosenkoetter; Pamela Wise-Martinez; Joyce Jones and Frank Robinson Sr., Mathews-Dickey Boys & Girls Club; Alana Flowers; Bernie Hayes; and Isreal.

The images in this volume appear courtesy of the following sources:

Archdiocese of St. Louis Archives and Records (AR)
Artega Photos, LTD (AP)
Baltimore Sun, all rights reserved (BS)
City of St. Louis, Office of the Mayor: Raymond R. Tucker Records (OM)
Missouri Historical Society, St. Louis [History Museum] (MHS)
St. Louis American (SLA)
St. Louis Mercantile Library at the University of Missouri-St. Louis, Globe Democrat Collection (ML)
St. Louis Post Dispatch (PD)
St. Louis Public Schools Archives (PS)
St. Louis University Archives and Record Management, George Wendel Collection (SLU)
The State Historical Society of Missouri, Photograph Collection (SHS)
1966 Annual Report of the Urban League of St. Louis, Inc. (UL)
The Davis Family (DF)
Elise Novak (EN)
Tom Thompson (TT)
Bob Hansman (BH)

INTRODUCTION

In 1908, the DeSoto-Carr neighborhood just north of downtown St. Louis was getting attention among social reformers. The *Housing Conditions in St. Louis: Report* by Charlotte Rumbold and the Housing Committee of the Civic League of St. Louis lamented the "almost complete decrepitude" and appalling lack of sanitation in the neighborhood that lay just to the east of what would become Carr Square Village public housing for blacks in 1942. Only a few years later, and a few blocks farther west, this would also become the site of Pruitt-Igoe.

As the original black population of St. Louis increased during the Great Migration, a stunning array of policies—from the 1916 Segregation Ordinance to a proliferation of some 378 neighborhood restrictive covenants—forced the concentration of blacks into a few main neighborhoods, Mill Creek Valley being the first, along the east-west downtown core.

In the late 1930s, St. Louis began building two segregated low-rise public housing projects—Clinton-Peabody on the south side for whites and Carr Square Village on the north side for blacks. This period coincided with the New Deal programs (FHA, HOLC, and GI Bill) that, collectively, accelerated the flight of whites from cities.

By the mid-1900s, with the arrival of the highway system and urban renewal, something of a perfect storm began to develop in many older northern cities. In St. Louis, the storm was exacerbated by the 1876 divorce of the city from the surrounding county, land-locking the city and putting the effects of white flight on steroids. And when urban renewal and the highway system intersected with slum clearance, historic African American neighborhoods like Mill Creek Valley became ground zero for the storm.

In February 1951, at a meeting sponsored by the Urban League, Beatrice Wheeler Thomas, a seventh grade black teacher at Cole School, said, "I find it an increasingly difficult job to explain [to students] the meaning and ideals of democracy in the face of the contradictory, undemocratic and un-Christian-like practices of segregation."

Mill Creek Valley was declared blighted; eminent domain was invoked. Between 1955 and 1959, Mill Creek Valley would be completely wiped out—several square miles near the heart of the city—and replaced by Highway 40. What would enter was something of a second phase of public housing—where people would go as their neighborhoods were being destroyed.

Just to the north of the ill-fated Mill Creek Valley was DeSoto-Carr, already the focus of long-standing concern, and considered by many to be one of the other worst slums in the city. Soon all the pieces would fit together.

Mayor Joseph Darst, who was elected in 1949, had been impressed with New York City's high-rise housing and preferred it to St. Louis's low-rise buildings. "Children given the opportunity of residing under healthful community conditions and rescued from the squalor of slums will have greater physical, spiritual and economic strength to carry on the traditions of democracy," he said.

In 1950, the theme of "Progress or Decay" beat like a drum in the local paper. As Cochran Gardens, the first high-rise public housing in St. Louis, was being built, beginning in 1952, it was

touted as "St. Louis' Answer to *Progress or Decay*." A May 9, 1952, Public Housing Week mayor's proclamation and brochure announced, "St. Louis Chooses Progress." Two weeks later, on May 23, ground was broken for Pruitt.

Clinton-Peabody and Carr Square practiced racial segregation; Cochran Gardens was designated for whites only. And Pruitt and Igoe were being planned as segregated. The Pruitt Homes would be 20 eleven-story buildings for black folks, just over the rise to the north of Mill Creek Valley; the Igoe Apartments would be 13 eleven-story buildings for whites, just north of Pruitt across Dickson Street. (Echoes of the Mason-Dixon Line seem unavoidable.)

The *Davis et al v. The St. Louis Housing Authority* lawsuit challenged segregation in public housing. While whites were being signed up for Cochran Gardens, blacks were being held, on a separate list, for Pruitt. Prospective black tenants, including World War II veterans, approached Valla Abbington and the NAACP, but informal talks with St. Louis Housing Authority (SLHA) broke down. On June 20, 1952, Robert Witherspoon, Frankie Freeman, and the NAACP filed suit; Freeman became lead counsel. As the *Davis* case was winding through the courts, Pruitt and Igoe were being built.

Resident capacity numbers vary, with 11,000 generally being the low end and 15,000 being the startlingly high end. Between 11,000 and 12,000 seems like the best estimate. But whichever figure one uses, full occupancy was never reached. The peak seems to have been around 91 percent. Pruitt-Igoe had the lowest occupancy rate of any public housing in the United States.

Blacks began moving into Pruitt in 1954; whites began moving into Igoe in 1955. Some blacks moved into Igoe as well, perhaps anticipating the *Davis* decision (based on the *Brown* precedent). The first families in Igoe were four white and three black. Two *Davis* plaintiffs were offered housing in Carr Square; others left the suit. Eventually, there was just one plaintiff: Sedell Calvin Small. Two days after Christmas in 1955, Judge Moore ruled in his favor. SLHA was "forever enjoined" from "refusing to lease or rent to qualified Negro Applicants any units of public-housing projects . . . because of [their] race or color." This meant that Igoe, named for a white congressman whom the *St. Louis Argus* called "A Friend of Our Race and People," would officially be integrated.

For the first few years, some white folks did, indeed, live in Igoe. But their numbers soon dropped off, and Pruitt-Igoe became, for all intents and purposes, entirely black. A number of ticking time bombs began to surface—everything from cost-based design concessions, to funding and maintenance policies, to Housing Authority and ADC policies, to the reshaping of the neighborhoods and the city around it—and began to play out in Pruitt-Igoe. Money and services showed up—playgrounds, a community center, policing, local volunteers, neighborhood churches, and other religious institutions—and for several years the sense of camaraderie and home coexisted with the ticking time bombs. But with time came increasing vacancy, increasing erosion of the physical and social fabric, as well as crime—some from within, much from without—and ultimately tragedy. The murders of two little girls only months apart finally made it horrifyingly clear that *something* had to be done.

During the early 1970s, what was left of Pruitt-Igoe became a battleground between local and federal interests. Several implosions of buildings took place, the first initially to test possible redesign ideas. But by 1974, all those plans were abandoned, and by 1976, the site was once again vacant land—a kind of perversely sacred ground, soaked in tears and blood.

What had begun as the DeSoto-Carr neighborhood, which had been erased for Pruitt-Igoe, which had in turn also been erased, soon became a dumping ground for the remains of other city neighborhoods that were being erased as well. And ultimately, over the decades, nature did its part and turned the entire site into a forest.

What follows strives to get beyond the aerial images and broad-brush arcs of the story of Pruitt-Igoe, to get back down on the ground and recall some of the finer grain detail of what actually happened there. It is, above all, a story of resilience.

One

A Pleasant Surprise Is in Store for the Tenants

"Extremely obsolete" is how Harland Bartholomew's city plan described the DeSoto-Carr neighborhood in 1947. That same year, in June, Elwood Olds's *Graphic Facts* cited a decaying urban core, a critical housing shortage, and population loss to the suburbs. "The worst conditions are found in the city's highly concentrated Negro district . . . [with] by far the highest infant death rate," the report said. (SHS.)

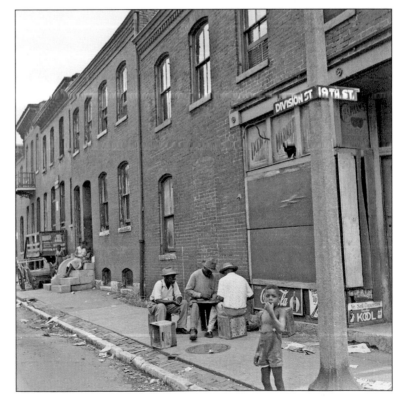

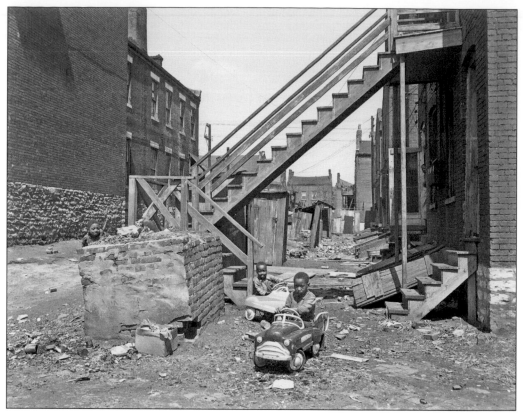

In 1949, the Urban League sponsored a study of black housing by the head of Stowe Teachers College's Department of Sociology, Frank Bowles, and students. John T. Clark, of the Urban League, wrote Mayor Darst that (quoting the *Post-Dispatch*) "not a single house, flat or other similar accommodation is vacant or for rent in an area of 60 city blocks populated by Negroes." The *Post-Dispatch* ran its *Progress or Decay* series in 1950. Without decent housing, said Norman Seay, area council chairman of the Federation of Block Units of the Urban League, in 1951, "the colored person has no chance to succeed or live a full life." Land in the DeSoto-Carr neighborhood was cleared. (Both, SHS.)

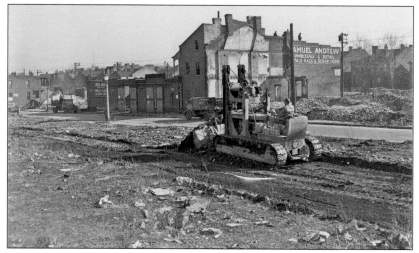

Ground was broken for Pruitt on May 23, 1952. Participating in the ground-breaking were Mayor Darst himself (who showed up with friends the following February to check on progress) and Arthur Blumeyer (both of whose names would be given to other upcoming public housing projects). Mayor Darst is on the left in this image, and Arthur Blumeyer is the tall man in the middle. Melanie Pruitt, the mother of Wendell Pruitt—an Air Force hero, Tuskegee Airman, and a graduate of Sumner High School (which began in Mill Creek Valley in 1875 as the first black high school west of the Mississippi River)—also participated. Wendell Pruitt had been killed in a plane crash in 1945. His "name will live," wrote a local paper. (Right, ML; below, MHS.)

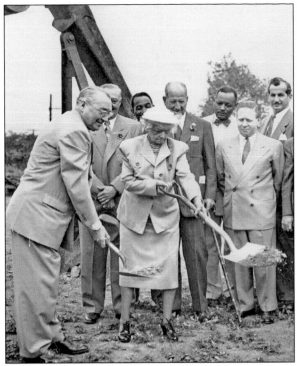

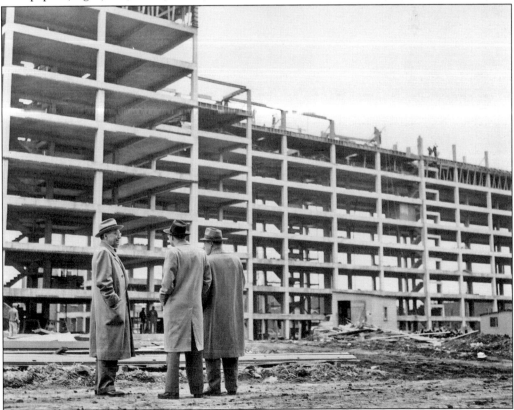

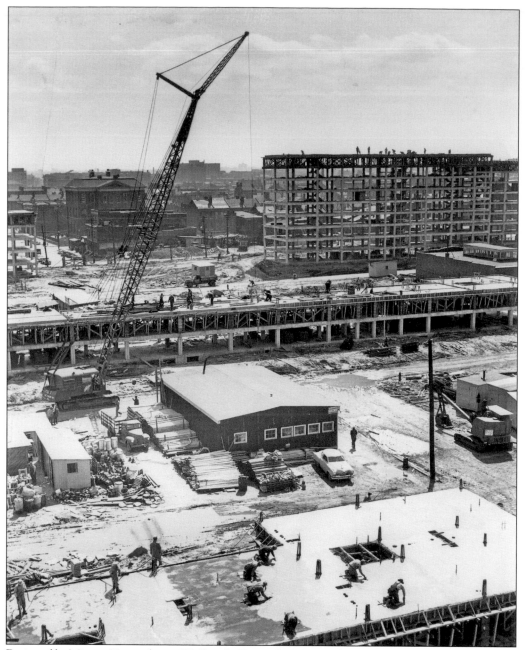

Designed by Minoru Yamasaki—of Hellmuth, Yamasaki & Leinweber—but dangerously compromised by cost-fueled Public Housing Administration density increases (from 32 families per acre in DeSoto-Carr to 55 in Pruit-Igoe) and "amenities" cutbacks, the seeds of Pruitt and Igoe's failure were already present. Wrote Yamasaki years later, in 1972, "I am perfectly willing to admit that of the buildings we have been involved with over the years, I hate this one the most. There are a few others, but I don't hate them; I just dislike them." Most DeSoto-Carr residents rented and were evicted as Land Clearance for Redevelopment Authority took title to the properties, with most residents being on their own regarding relocation. A few seem to have gotten assistance if they wished to "return" to the new public housing. (ML.)

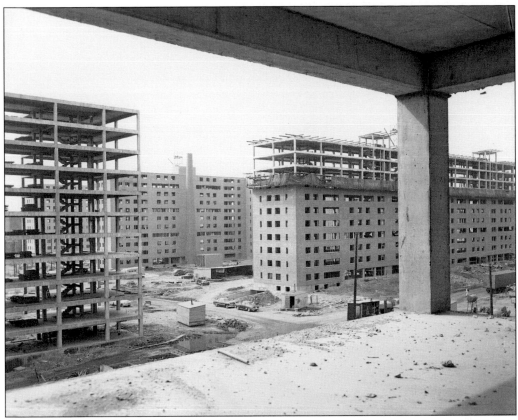

The stairwells, which would be much used due to the skip-stop elevators stopping only at every third floor, would become, over time, sites of danger and crime and ultimately, in 1971, a murder that would bring the entire enterprise to a point of reckoning. (Both, MHS.)

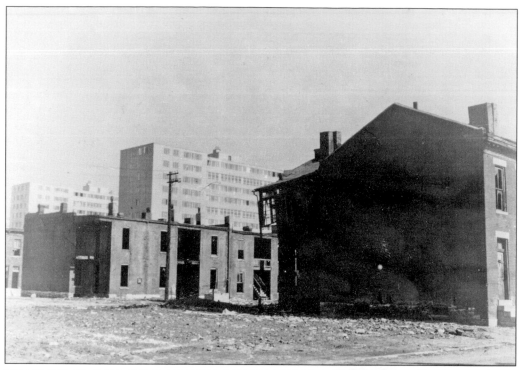

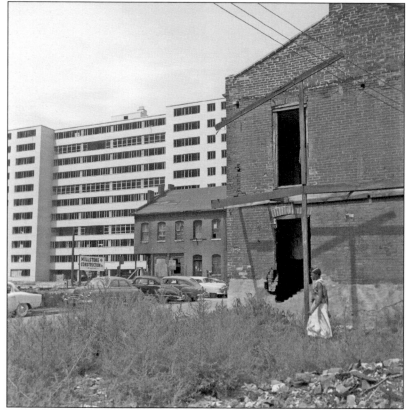

But few people were thinking about such things at the time. Most people's minds were on the promise of better housing and the stunning contrast of this new "city within the city" to the neighborhood surrounding it. (Above, MHS; left, SHS.)

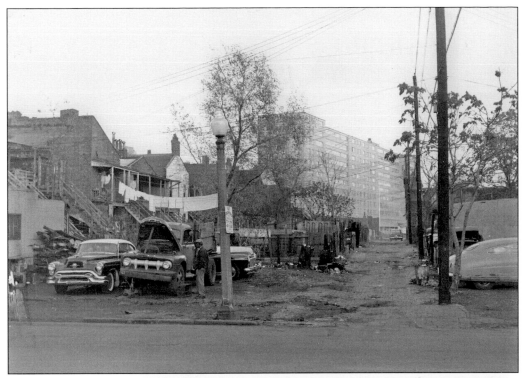

George Hellmuth, of Hellmuth, Yamasaki & Leinweber, declared that Pruitt-Igoe would be "up-to-the-minute in every respect on the basis of present standards. Whatever public housing is built in the future will be even better." And the *Post-Dispatch* proclaimed, "A pleasant surprise is in store for the tenants." (Above, MHS; right, SHS.)

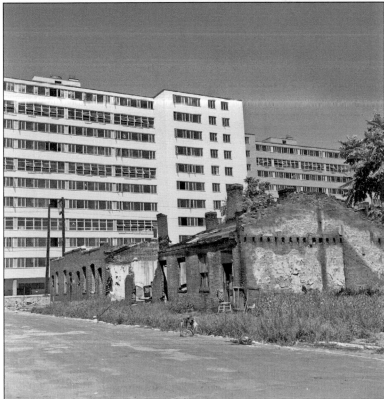

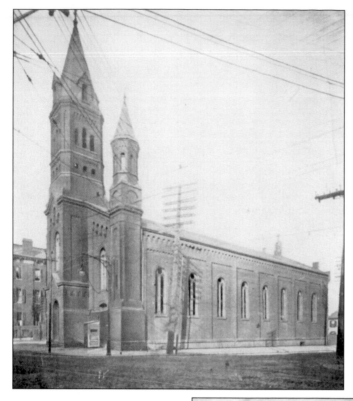

Pruitt and Igoe were going up in a neighborhood that had once been the Kerry Patch, a poor and largely Irish area anchored by several large churches, including St. Bridget of Erin, which opened in 1853 at Jefferson Avenue and Carr Street, at the southwest corner of Pruitt; and St. Leo's (1888), just a block north of Cass Avenue, the northern edge of Igoe. St. Stanislaus Kostka (1891), a Polish church, was also nearby, on Twentieth Street, forming a visual terminus for the eastern end of Dickson Street, but its story would remain less entwined with Pruitt-Igoe than would St. Bridget's and St. Leo's. (Both, AR.)

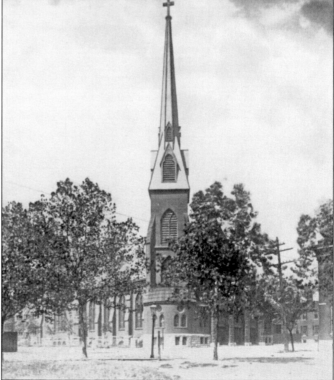

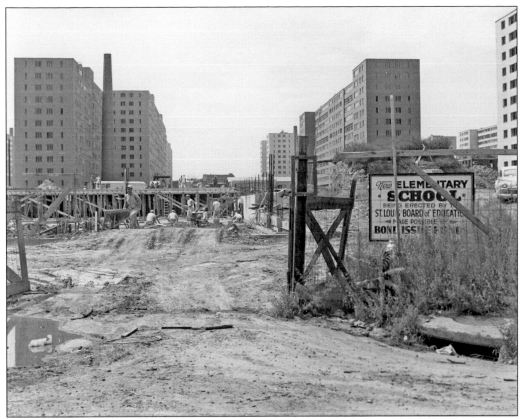

As the Pruitt Homes were being built, an elementary school, also named for Wendell Pruitt, was being constructed on Twenty-second Street, near the southeast corner of the development, to serve the children of the new housing project. Mayor Darst died in 1953, just after leaving office. William Igoe also died in 1953. Also in 1953, as Pruitt-Igoe was going up, Chestnut Valley, an area adjacent to Mill Creek Valley, was coming down. Mill Creek Valley itself would be next. (Above, SHS; below, MHS.)

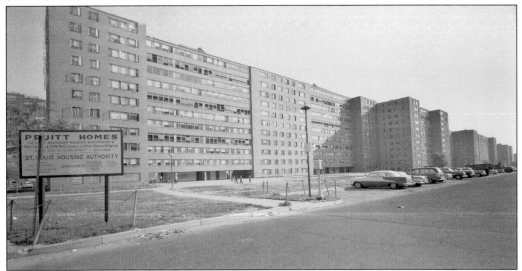

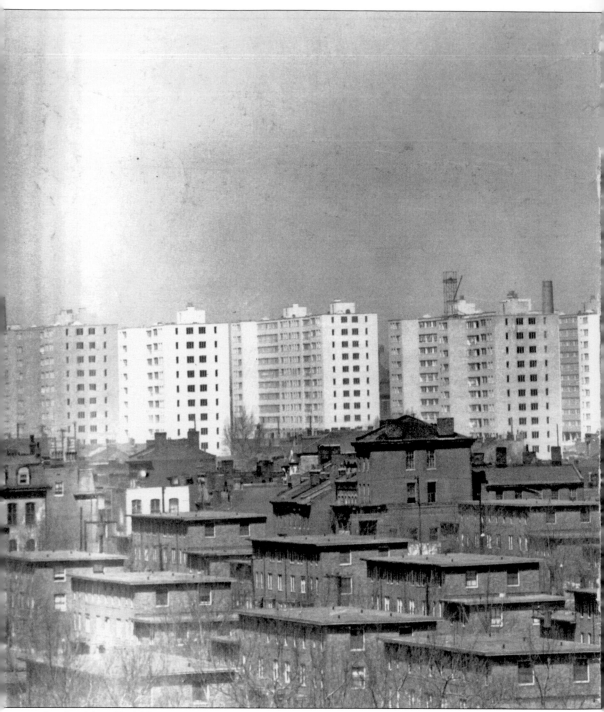

In this May 10, 1954, view, Pruitt, for blacks, on the left, is completed; Igoe, for whites, on the right, is still under construction. Carr-Square Village—the black counterpoint to Clinton-Peabody for whites—is in the foreground. In response to the *Davis* lawsuit, SLHA wrote that Cochran Gardens "was constructed in the neighborhood . . . predominantly inhabited by persons of the Caucasian race. The development contracted for was planned . . . to conform to the community

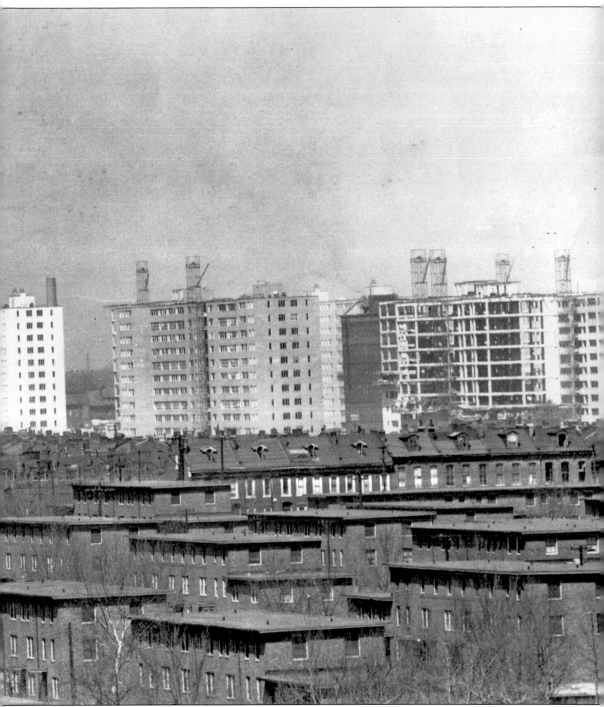

pattern." Echoing the 1916 Segregation Ordinance, SLHA said they "had a duty and responsibility under the law to preserve peace and order in the community for the protection and welfare of both races and, in the interest of public safety, to prevent racial conflict and violence. . . . The policy of [segregated housing] is reinforced by recognized natural aversion to the physical closeness inherent in integrated housing." (ML.)

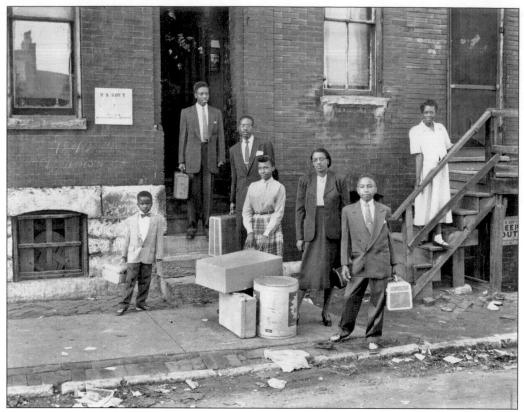

On October 11, 1954, the first family moved from their tenement at 1840A Division Street into Pruitt, on the 10th floor of 2431 O'Fallon Street. The family consisted of Frankie Mae Raglin, who would play a significant role in Pruitt-Igoe later on; her son Phillip Cohran, 27, by a previous marriage; and her four nieces and nephews, orphaned children of a war veteran. They were Charles Green, 7; Marion Green, 12; Ann Green, 15; and David Lee Green, 17. She said Pruitt was "perfect, the nicest place I'd ever had. Back in Mississippi I'd had a house but it was an old house. I'd never had any place—never seen any place—as nice as Pruitt." (Both, PD.)

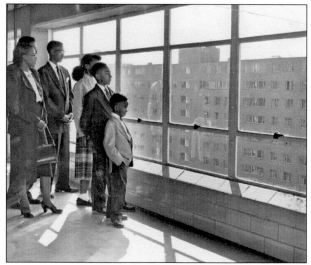

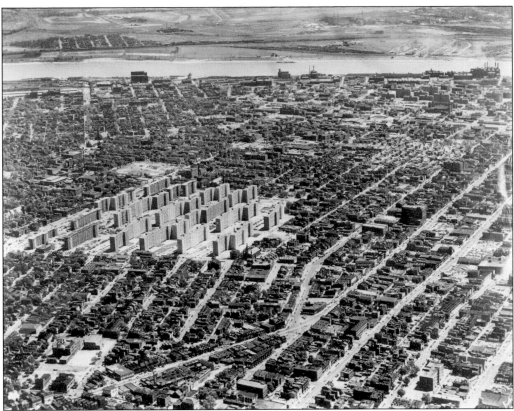

Pruitt and Igoe stood out from the rest of the city: 33 eleven-story buildings on a little over 57 acres. They looked—and soon became—like nothing else in the city. Photographers were on hand for the move-in. Two photographs in particular would become iconic Rorschach-like images: the Raglin family looking out the 10th-floor windows at Pruitt in one image and at the old Desoto-Carr neighborhood in the other. (Above, PD; below, ML.)

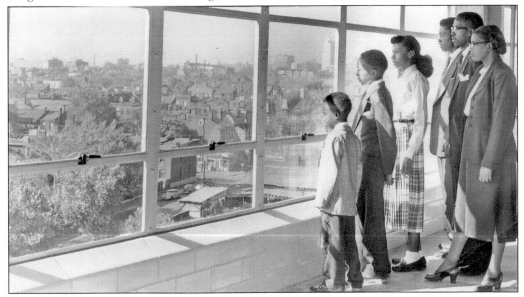

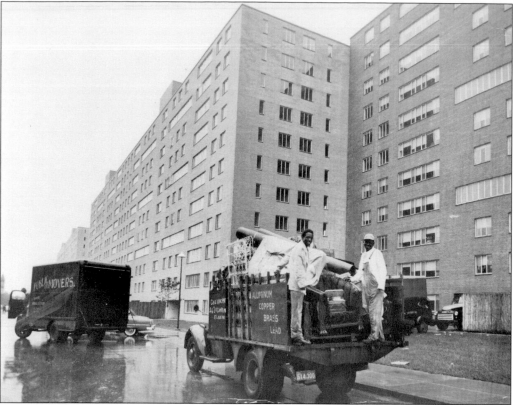

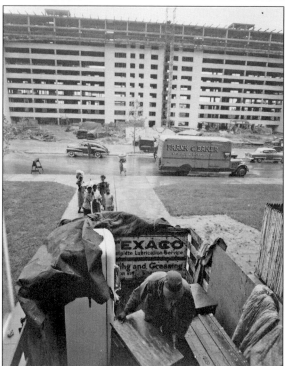

On October 17, 1954, it rained, but the weather did not stop the line of trucks that backed up as black families waited to unload their furniture at the entrances of the first building to open in Pruitt. The construction of Igoe, slated for whites, was still under way. One of the people moving into Pruitt that first year was Ruby Russell, who would go on to play a major leadership role in all the subsequent phases of Pruitt-Igoe. (Above, PD; left, SHS.)

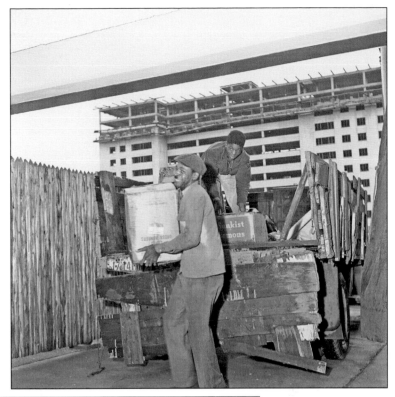

People checked in and began moving in. (Both, SHS.)

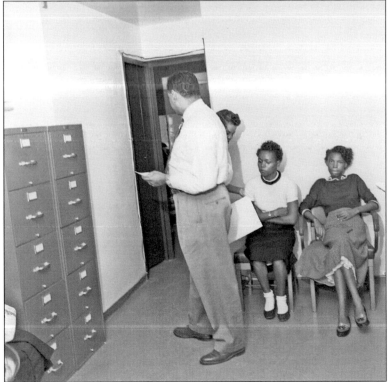

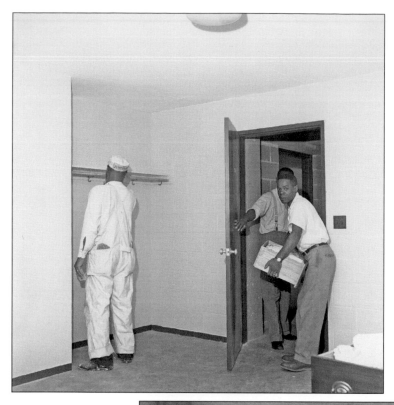

Workmen were still
sprucing up the place
as the first residents
were moving in.
(Both, SHS.)

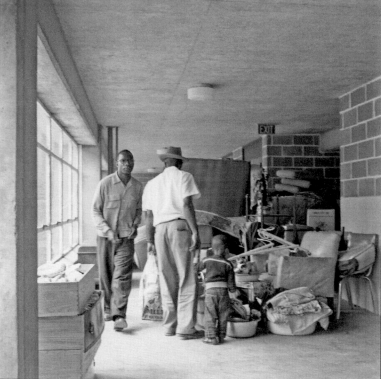

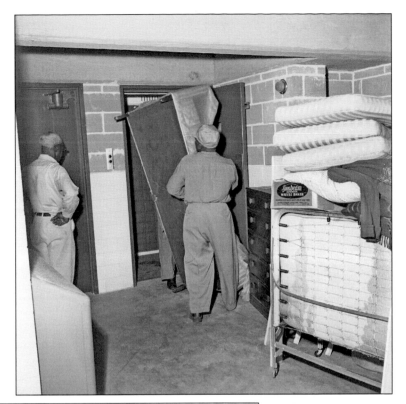

Friends and workmen were on hand to help people move, set up furniture, and hang drapes. (Both, SHS.)

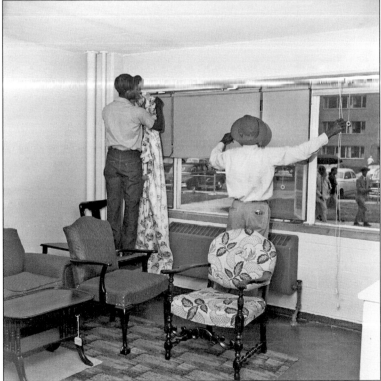

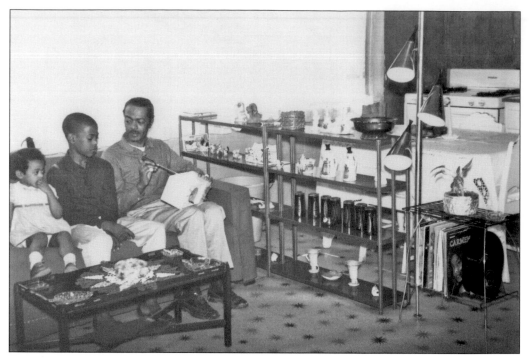

For many, this was a home nicer than anything they had before. Some had not had indoor plumbing. Folks like Edward Smith could finally provide some of the "modern" amenities for his children. But while many of the families that needed housing were large, with lots of children, most of the units in Pruitt were small—a mismatch that would have serious consequences. (Both, MHS.)

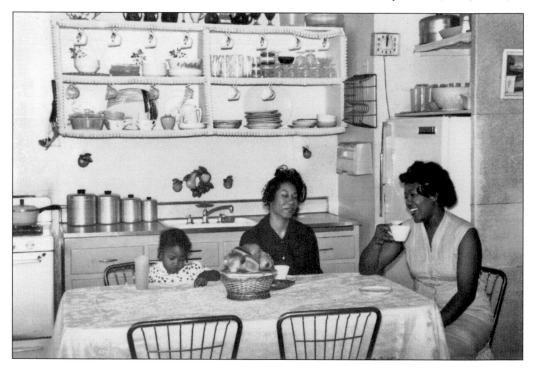

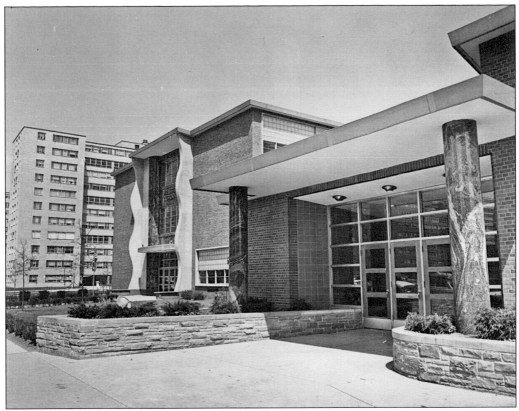

Pruitt School opened its doors for the children living in the new housing development. Day and night, the Pruitt Homes and Pruitt School were visible just outside each other's windows. (Both, PS.)

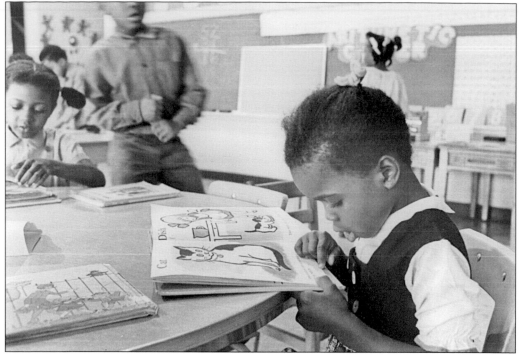

To complement Pruitt Elementary (above), the Pruitt-Igoe Day Nursery opened at 2328 Biddle Street. In May 1955, the same month the Pruitt four-year-olds below were photographed playing in their new sandbox, voters approved a bond issue to tear down Mill Creek Valley. On July 23, the first families moved into Igoe. Also in 1955, as the story of Emmett Till was unfolding nationwide, a Municipal Heath Clinic was built across the street on Jefferson, offering comprehensive child health care, prenatal classes, obstetrics, family planning, X-rays, and tuberculosis treatment. (Above, PS; below, ML.)

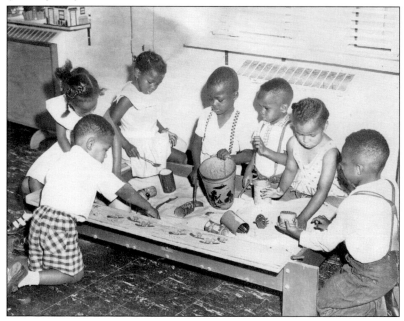

On November 25, 1955—even before Igoe had officially opened—during a scuffle in an apartment, 12-year-old Betsy Bates, the daughter of Mr. and Mrs. Melvin Roberts, fell from a ninth-floor window at 2143 O'Fallon Street in Pruitt. She was taken to Homer G. Phillips Hospital, the "colored hospital," suffering internal injuries and a broken leg. The fact that she fell into a wet, muddy area probably saved her life. A 24-year-old man was held on suspicion of assault. Three months later, on February 26, 1956, Igoe—Hellmuth, Obata & Kassabaum, architects, but working with Yamasaki's designs—celebrated its official opening. (Right, ML; below, PD.)

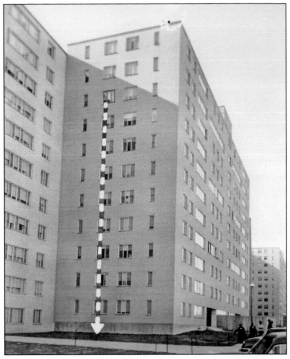

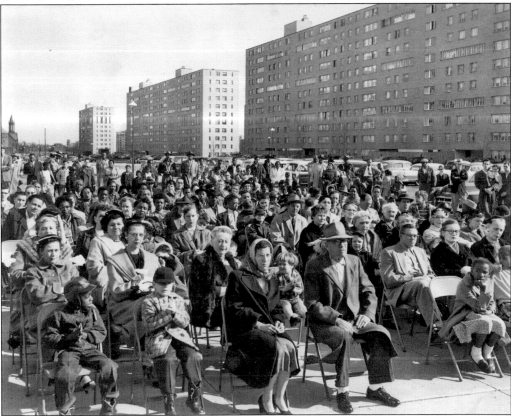

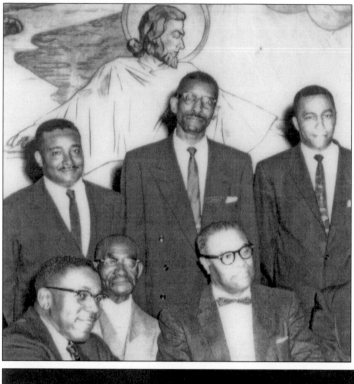

Richardson's Delicatessen, at 2411 Cass Avenue, and Keller's Supermarket, at 2319 Cass Avenue, both opened in 1956, just north across Cass Avenue from Igoe and just a block south of St. Leo's. Also in 1956, Rev. Joel Kelly Davis founded Grace Missionary Baptist Church, at Twenty-second and Cole Streets, just a block or so south of Pruitt-Igoe. Reverend Davis is pictured at left, second row, far right. In September of the same year, a City of St. Louis exhibit at the Mid-America Jubilee at the riverfront featured a dramatic photograph of Pruitt-Igoe by Greer Cavagnaro. (Left, DF; below, OM.)

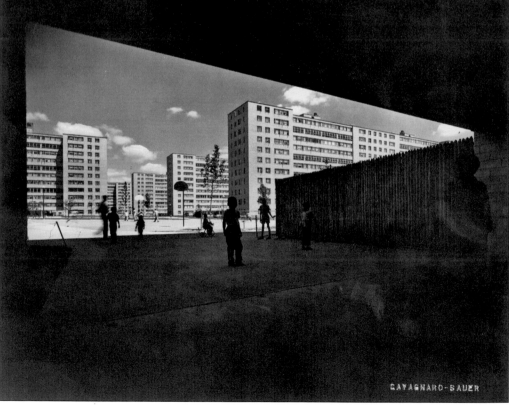

CAVAGNARO-SAUER

Designed for use by 20 families, the galleries were envisioned as "vertical neighborhoods"—as close, safe playgrounds for small children while their mothers did housework or laundry; as open-air hallways; as porches in warm weather with summer breezes blowing through; as a laundry, including both coin-operated automatic washers and handwashing machines, and two drying yards; and as storage, with each family having a storage bin in the central area just off the elevator. Down below, children could also play outside at the Pruitt-Igoe Day Nursery. (Both, MHS.)

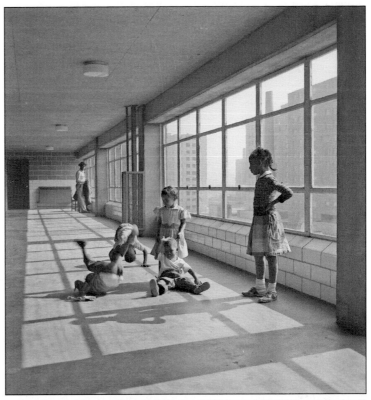

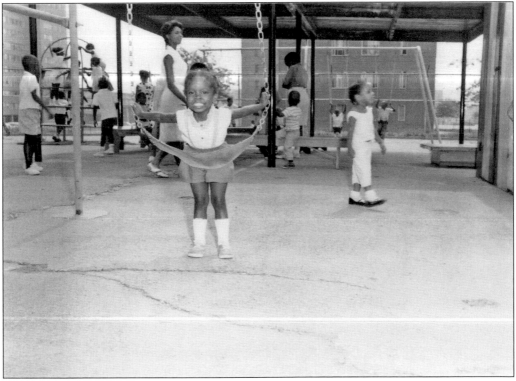

For the first few years, whites and blacks both resided in Igoe. In 1957, each of the public housing projects had a housing manager; John Maguire was the housing manager for Pruitt-Igoe (training in Pruitt, then managing Igoe). He held monthly meetings with his staff, which included a building service foreman, two cashiers, two clerk-typists, a chief custodian, two home service visitors, and Maguire's assistant, Victoria Cothran (below, far right). (Left, MHS; below, PD.)

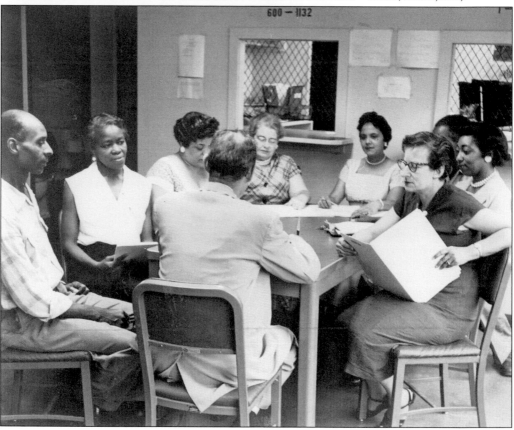

Maguire conducted regular housekeeping inspections, accompanied by service visitors, looking under rugs and checking for violations of cleanliness rules. Habitual violators were given 90 days to find other living quarters. On his rounds, Maguire would spend time with his residents—like 69-year-old Anna Caito, who fixed him coffee and pastries and conversed with him in Italian, and 74-year-old George Lyons, a retired interior decorator bedridden with arthritis. Maguire had also learned sign language, which he used to communicate with deaf tenants like Alcena Hawk. Pruitt-Igoe's occupancy peaked around this time, 1957, at 91 percent. (Both, PD.)

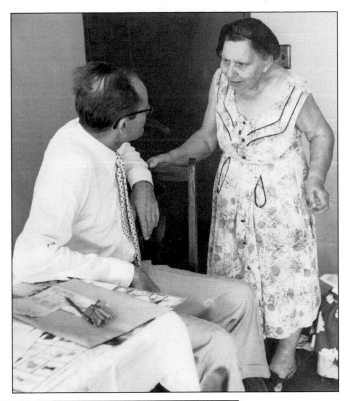

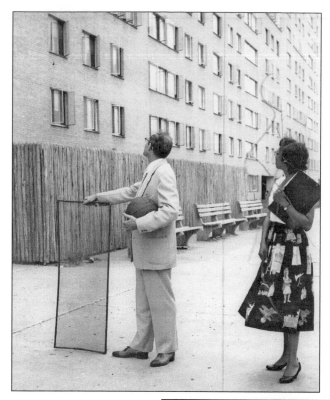

On this particular inspection trip, Maguire found a screen lying on the sidewalk and looked to see what window it had come from. He had previously taken a basketball from boys playing in a corridor and told them he would return it in a week. Increasingly, the galleries were becoming areas of uncertain ownership. They were also far away from the outdoor areas where children played and, over time, engaged in other activities. It became hard to keep an eye on what was happening in those vast open spaces so far below. April 1958 brought increased police officers, a new manager, and "jimmy-proof" locks for every apartment in Pruitt and Igoe. (Left, PD; below, MHS.)

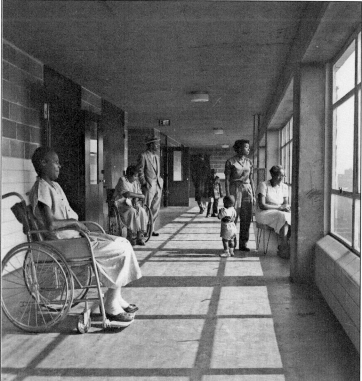

"We have noticed a gradual decline in serious crime," said Donald Lowe, St. Louis Public Housing management director. Acting police commander Lt. L.L. White reported serious crime "tapering off." By 1958, some police were calling the area the "New Korea," but largely because of Friday and Saturday night peace disturbances, and a *Globe-Democrat* story that same year reported that crime now was mostly peace disturbance and vandalism. The photograph below shows patrolman Nate Jordan of the Carr Street District making a report of broken windows at Pruitt. Pruitt School is visible through the windows. (Above, MHS; below, ML.)

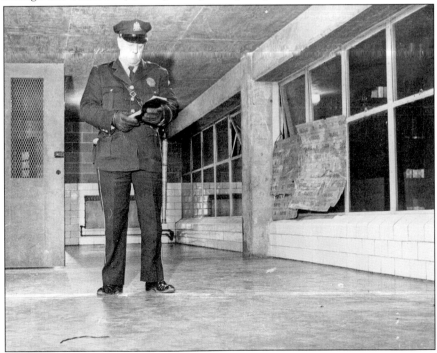

In 1958, a new Community Center was proposed; little by little, things that had been eliminated from the original plan were being brought back. "A Negro woman, once illiterate, now a leader in tenant affairs of her housing project," was quoted in a newspaper account. She said, "Every night I get down on my knees and thank God for public housing. The money my husband and I save is sending our two children to college. Some go bad in here, but others like my children, may grow up to become important American citizens." (Above, ML; below, MHS.)

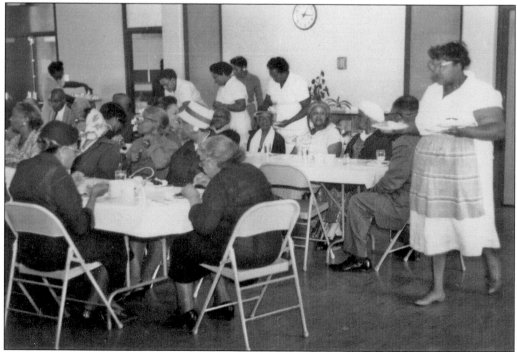

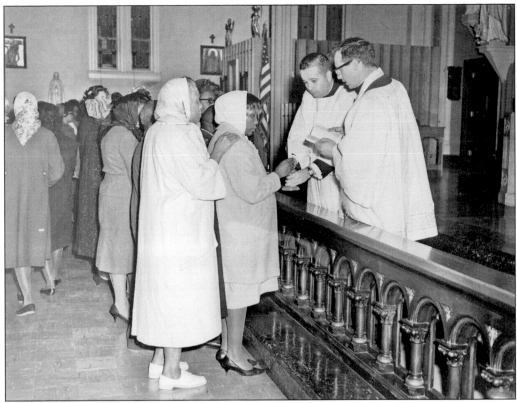

Many residents of Pruitt-Igoe attended services at St. Bridget's. However, much of the socializing remained segregated. Each year, fewer whites lived in Igoe. After several years, they were basically gone. (Above, AR; below, MHS.)

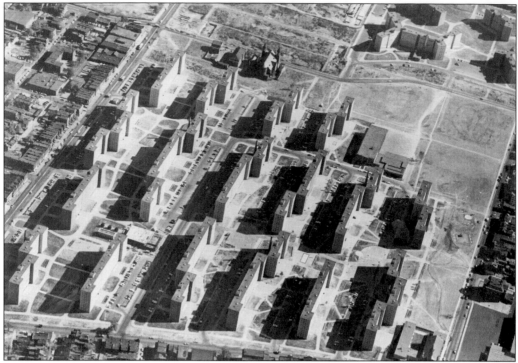

DeSoto Park (the vacant area near the top right of the aerial photo, in which left is north) had been built just south and east of Pruitt School (the flat buildings in the corner of the park). Vaughn Public Housing, part of which is visible in the very top right corner, was built right after and right across Twentieth Street from Pruitt-Igoe. Also visible in the photograph above are the Community Center (the flat building tucked between two high-rises on the left), St. Bridget's (in the lower right), and St. Stanislaus (top center). St. Leo's is just out of view on the left (north) side, across Cass Avenue, in what was still a neighborhood of intact buildings. (Above, PD; below, SHS.)

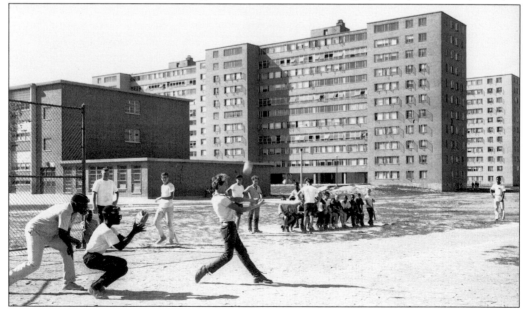

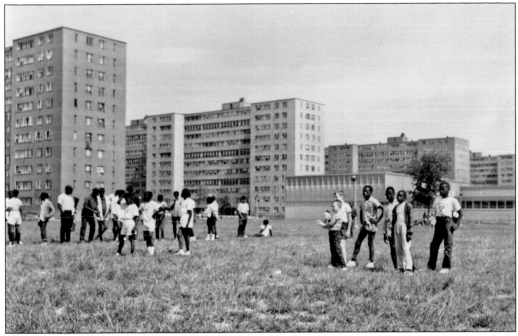

DeSoto Park became (and still is to the present day) the site of frequent games and athletic events. The DeSoto Center would be built at the northern edge of the park, just northeast of Pruitt School and south of St. Stanislaus. Pruitt-Igoe boasted several baseball teams, including the Pruitt Stars and the Igoe Bums. (Both, MHS.)

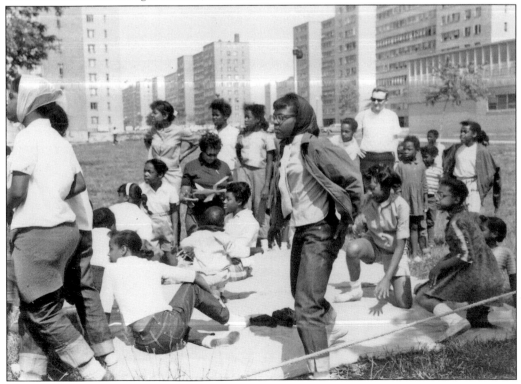

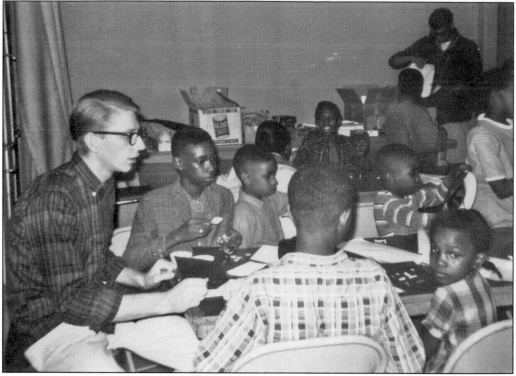

People would come to Pruitt-Igoe to give classes, like the Luther Christmas Crafts class, seen above on December 12, 1965, at the new Community Center, to participate in athletic events . . . and to do research. The Pruitt-Igoe sports teams and athletes won their share of trophies. The baseball league would still be getting them (below) in February 1970 at a Mathews-Dickey Boys Club benefit dinner. But that was still years in the future. (Both, MHS.)

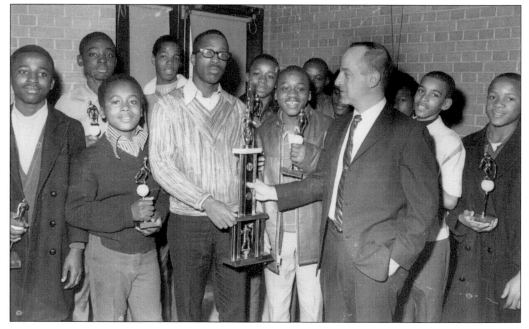

Two

OUR LIFE IS WHAT OUR THOUGHTS MAKE IT

The first Crunden Library, a few blocks east down Cass Avenue, opened in 1909 but closed in 1953 due to "encroachment of industry." In 1959, the same year as the Mill Creek Valley demolition, a second Crunden Library was built on Cass Avenue next to Pruitt-Igoe. The eastern end of the project was now flanked north and south by Crunden Library and Pruitt School. (SHS.)

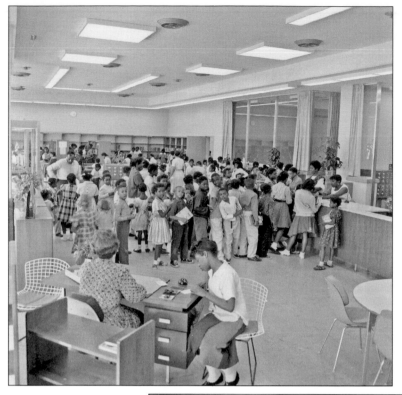

A typical featured book at Crunden Library was *Segregation and Desegregation—A Christian Approach* by T.B. Maston. In it, he wrote, "Desegregation of the schools or of community life in general may or may not lead to genuine integration. Whether it does or does not will depend on the attitude of white and Negro people toward one another." (Both, SHS.)

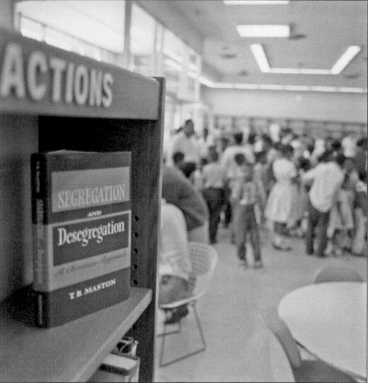

The east exterior wall of the library originally had a grid of letters and numbers. The northeast corner still has a stone plaque with a Marcus Aurelius quote: "Our life is what our thoughts make it." Also in 1959, SLHA hired private watchmen with German shepherds to patrol. On July 27, 1960, a teenage thief ran into Pruitt-Igoe; a crowd of several thousand persons gathered, some shouting "Don't shoot that boy!" Police used dogs to quell the disturbance. Some Pruitt-Igoe residents began seeking private housing. (Right, SHS; below, ML.)

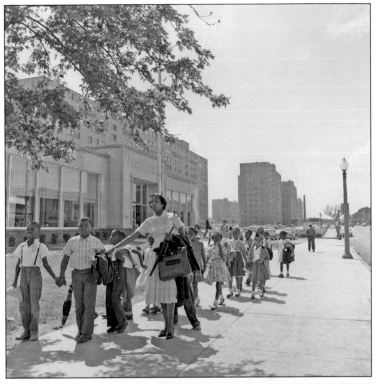

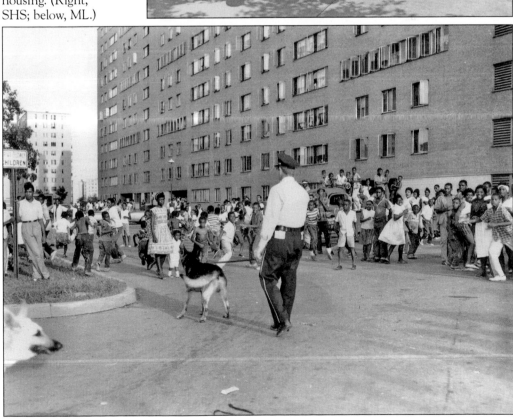

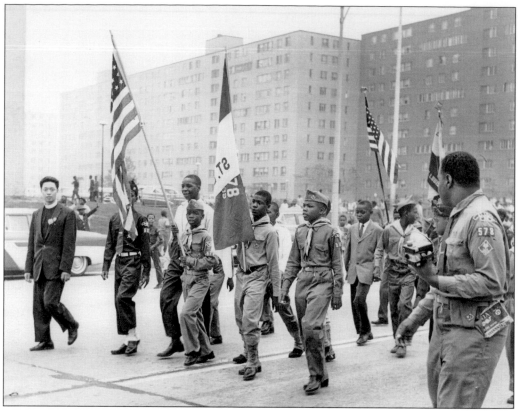

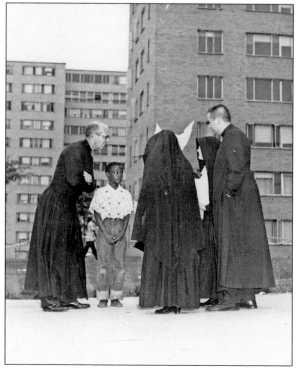

In 1960, Rev. Paul Chang, scoutmaster for Pruitt-Igoe Troop 578, led the annual observance in honor of Wendell Pruitt. Grace Baptist Church moved from the south side of Pruitt-Igoe to the north, 2323 Cass Avenue, a green two-story house-church next to Keller's. Brother Cotton lived upstairs. By 1971, Grace Baptist would be referred to as "The Pearl of Cass Avenue" and one of the "Pruitt-Igoe churches," along with St. Bridget's and St. Leo's. In 1961, Fr. John Shocklee (left) was appointed pastor of St. Bridget of Erin Church at the southwest corner of Pruitt-Igoe. Rev. Donald Heck (right), a young seminarian at the time and closely associated with Holy Guardian Angels at Clinton-Peabody, worked with Father Shocklee. (Above, ML; left, AR.)

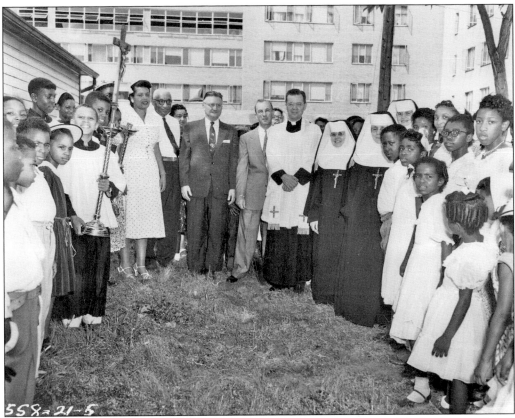

In 1962, Reverend Shocklee's duties expanded to include administrator of St. Leo's, just a block north across Cass Avenue from Pruitt-Igoe. Even as white flight and westward migration were changing the city, churches like St. Bridget's and St. Leo's stayed and took on a neighborhood mission, sometimes in entertaining form. Sister Mary Thomasita, a music teacher from Gary, Indiana, was part of a summer-enrichment program for children in housing developments. Below, she is practicing along with the drum and bugle corps she was training. (Both, AR.)

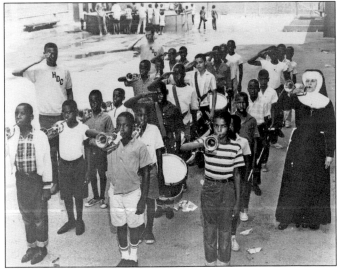

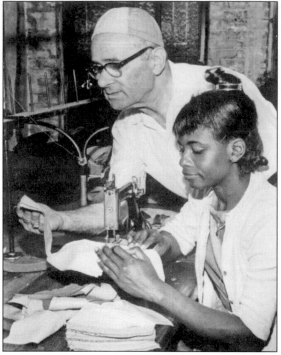

In 1962, the Department of Health, Education, and Welfare chose Pruitt-Igoe as the site for its first Concerted Services program. It provided funds for 45 social workers, day care, a health clinic, vocational rehabilitation, and a federally funded study of the tenants by a local university. At left, an 18-year-old girl with an intellectual disability is receiving instruction in the operation of a power sewing machine as part of her vocational rehabilitation training. She trained three hours a day for a month in preparation for on-the-job training at a cap factory. In 1963, Father Shocklee (below right) and the assistant pastor, Rev. Joseph Kohler (below left), who would go on to be executive director of Dismas House, ministered to Pruitt-Igoe. (Left, SHS; below, ML.)

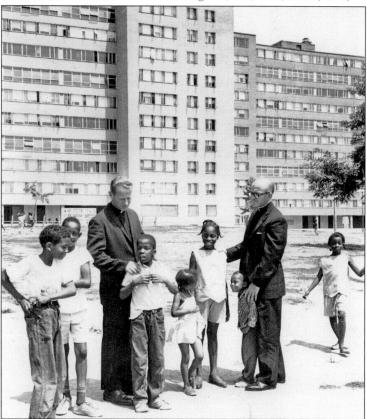

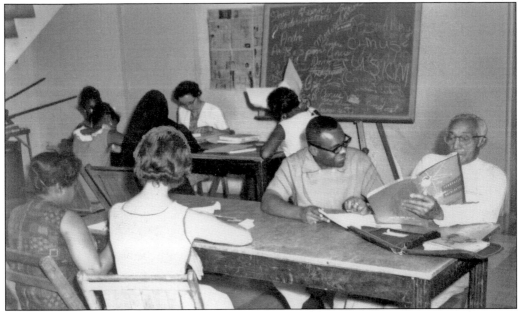

In 1964, Lyndon Johnson's War on Poverty began. Reverend Shocklee started the Bicentennial Civic Improvement Corporation, comprising 21 antipoverty programs, and offered services and adult education classes at St. Bridget's. Tutoring was also available in Pruitt-Igoe, as seen below. On July 2, 1964—two weeks after the murder of three civil rights workers in Neshoba, Mississippi—a young policeman named Paul McCullough was killed by Eddie Steve Glenn in a gun battle in Pruitt-Igoe; McCullough's son Robert would grow up to become St. Louis County's prosecuting attorney. By 1965, security was an issue. At any given time, there was one security guard for every 11 buildings and 3,000 people. (Above, AR; below, MHS.)

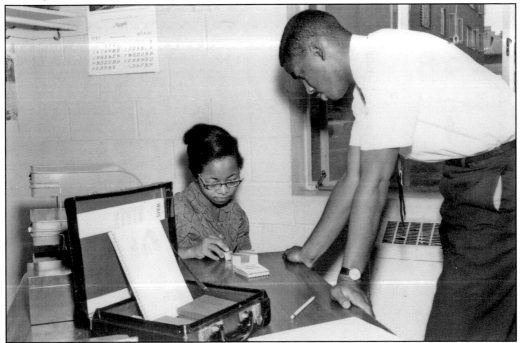

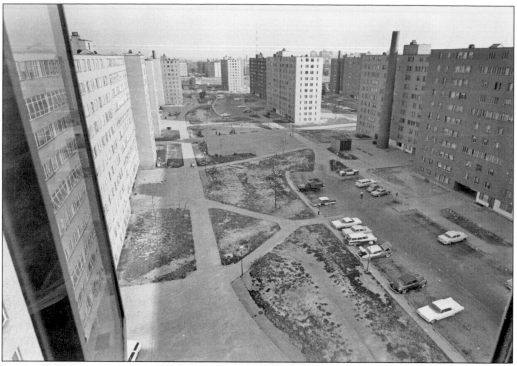

Between 1963 and 1965, the US military conducted secret zinc cadmium sulfide particle tests around St. Louis; the greatest concentration of the spraying was at Pruitt-Igoe. Rev. Robert A. Mayo said, "You sometimes get the feeling it is open season over there." Fr. Donald Heck said he rarely saw a guard in Pruitt-Igoe. He said he took five women to church at St. Bridget's with him, and when they came out they found his car had been broken into. All five women begged him not to report it because they feared reprisal. HUD money was provided for general repairs, structural changes, new lighting, and picnic and playground areas, giving back more of the things that had been eliminated from the original plans. The galleries by now were gauntlets. Children were being burned on the uninsulated pipes in the stairwells. (Both, PD.)

The vacancy rate was above 26 percent when these kids posed on a dumpster on Halloween in 1965, less than three months after the Watts riots. Renovation plans were in the works. Public toilets on ground floors would be another of the features restored after being cut from the original plans. Some residents set up small stores and candy shops in their apartments. But Pruitt-Igoe was still just across Cass Avenue from what many people considered to be one of the worst slum areas in St. Louis. In a few years, the area would be something of an epicenter for crime and gang activity, and some of it spilled into (and out of) Pruitt-Igoe. It became hard to keep children away from it. Beginning in 1965 and going for several years, the Missouri Early Childhood Program sent college students and adult volunteers to Pruitt-Igoe. (Both, PD.)

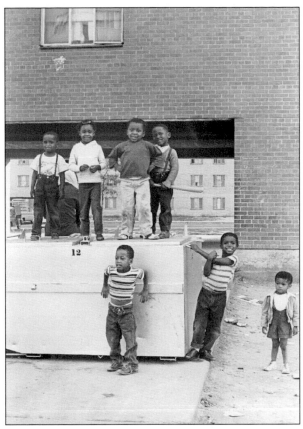

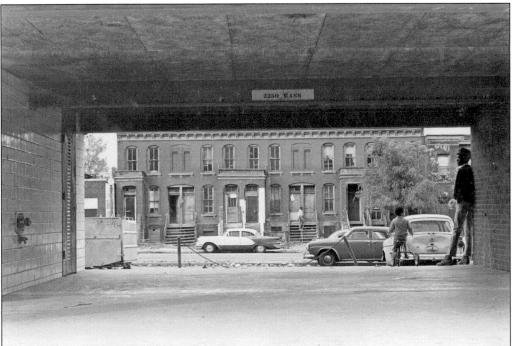

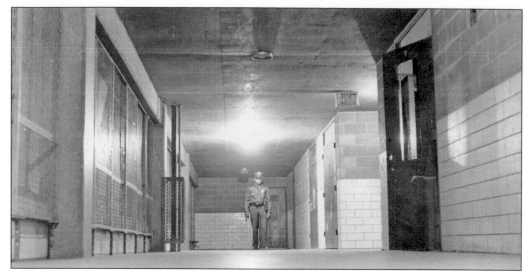

In September 1965, around 9,952 people lived in Pruitt-Igoe, two-thirds of them minors, and 2.5 times as many women as men. Only 74 percent of the 2,760 available apartments were occupied—the lowest public housing occupancy rate in the country. In December 1965, police, like Officer Dennis Blackman (above), began patrolling the stairways and corridors and grounds of Pruitt-Igoe from 6:00 p.m. to 2:00 a.m. daily. Pruitt-Igoe was becoming a place where residents and outsiders battled to determine their fate. For years, the tension of coexistence between these various forces would play out in Pruitt-Igoe. After the new baseball stadium opened downtown, the Pruitt Senior Citizens group would take bus trips to see the games—and then come back home to hallways patrolled by police. (Above, PD; below, MHS.)

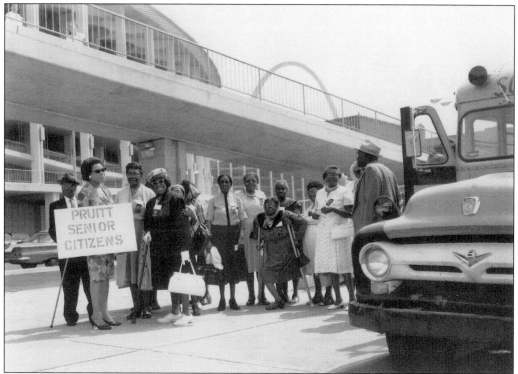

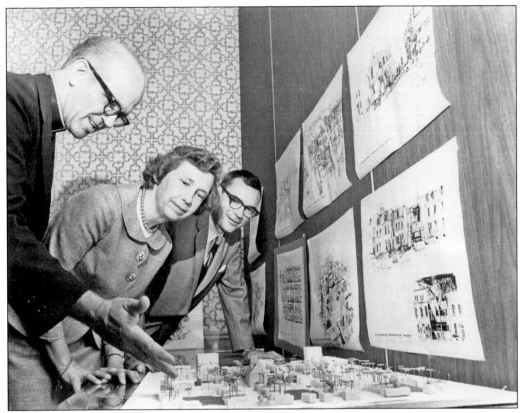

In March 1966, construction began on Yamasaki's World Trade Center—the "Twin Towers." In May, the League of Women Voters met at the Holiday Inn downtown. One of the topics of discussion was rehabilitation of the Mullanphy area near Pruitt-Igoe. Reverend Shocklee (left) attended, along with SaLees Smith Seddon, president of St. Louis Visitor Center, and Larry Kroll, community planner. Below, in June, William Boogor (far left) and Simon Werner (center), both SLHA officials, presented "do-it-yourself" clean-up equipment to Eugene E. Porter (right), chairman of the Pruitt-Igoe Neighborhood Corporation. (Above, ML; below, PD.)

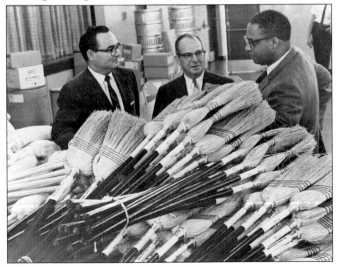

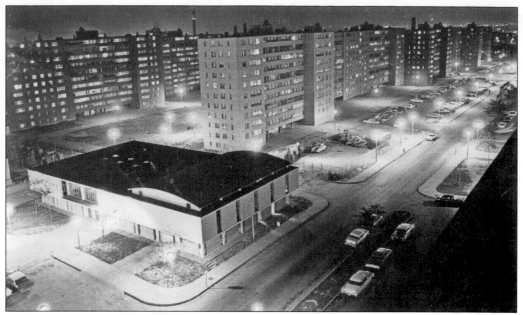

This October 1966 photograph shows the new lights around the Community Center and down Dickson Street. Dickson Street had been the dividing line between the 20 eleven-story Pruitt Homes for blacks to the south, and the 13 eleven-story Igoe Apartments for whites to the north. The Division of Welfare also had offices in Pruitt-Igoe; the Community Center was visible outside the windows. (Above, PD; below, MHS.)

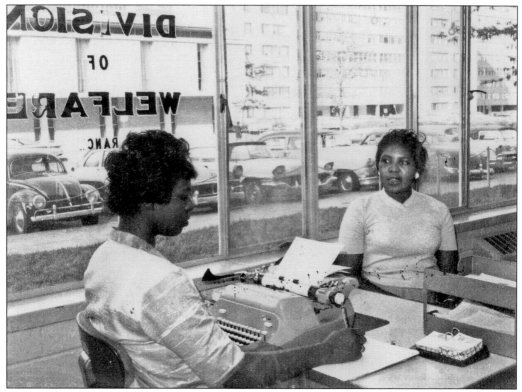

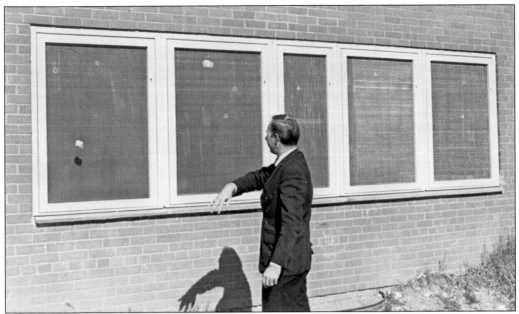

"The standard things on the market just didn't meet our problems," said Robert Gunter, development coordinator for SLHA. So, in October 1966, SLHA had "stone-proof," "unbreakable" items designed out of "a special material called butyrate" as part of a $7 million project to make Pruitt-Igoe livable. Here, a stone bounces off a new screen. Also in 1966, patrolmen Joe DeBisschop and William Ruedelin put on a self-defense demonstration for around 1,000 kids on Law Enforcement Day. The hit of the day was an obedience-training demonstration in a parking lot featuring a 100-pound German Shepherd named Parrish, who leaped through mockup windows, sniffed out a hiding fugitive, and nabbed a fleeing "robber," as Sgt. Robert Busch narrated the performance. (Both, PD.)

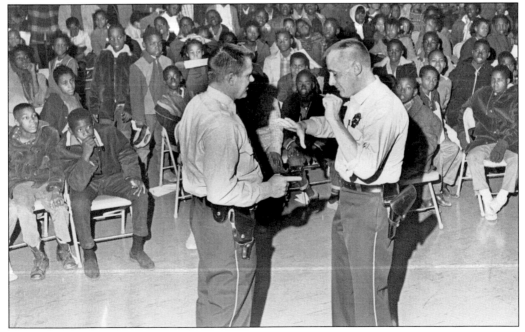

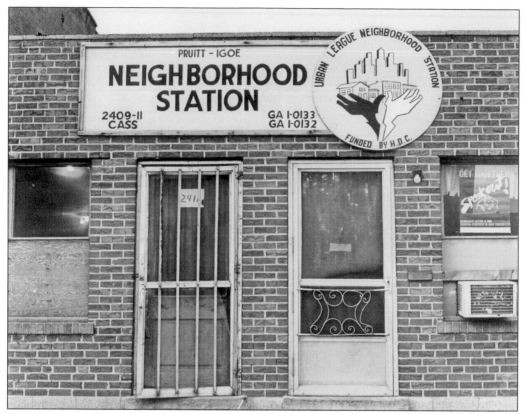

On November 3, 1966, the Model Cities Program began. Through a Model Cities grant, the Urban League opened the Pruitt-Igoe Neighborhood Station in the old Richardson Delicatessen building across Cass Avenue and next to Reverend Davis's house-church. Betty Thompson (below center) was one of the people who worked there, providing help with utilities, resumes and job placement, food and clothing, butter, and cheese. The sign in the window reads, "Get Together. Speak Out! Community action is you working together to help yourselves." Also in 1966, Jeff-Vander-Lou, Inc., was incorporated. Deeply committed to the community, Macler Shepard and Jim Sporleder were two of the guiding lights of Jeff-Vander-Lou. They would also play a role in later years, trying to save and reuse some of the vacant Pruitt-Igoe buildings. (Above, AR; below, UL.)

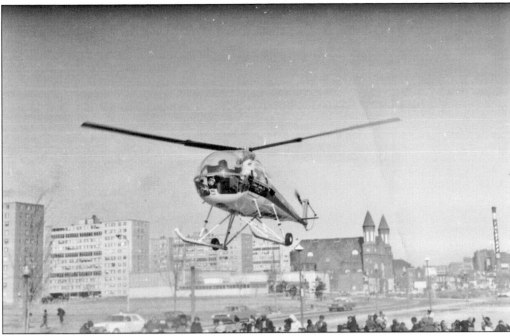

On December 17, 1966, Santa Claus paid a visit to Pruitt-Igoe—but by helicopter, not by sleigh. It was actually a Christmas party for the residents of the Vaughn public housing, just across the street from Pruitt-Igoe. But the kids from Pruitt-Igoe would not have missed this. DeSoto Field, the DeSoto Center, and St. Stanislaus are in the background. (Both, MHS.)

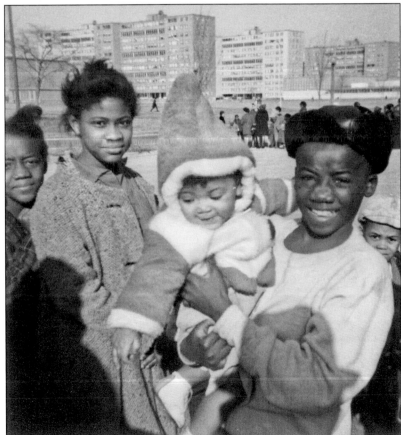

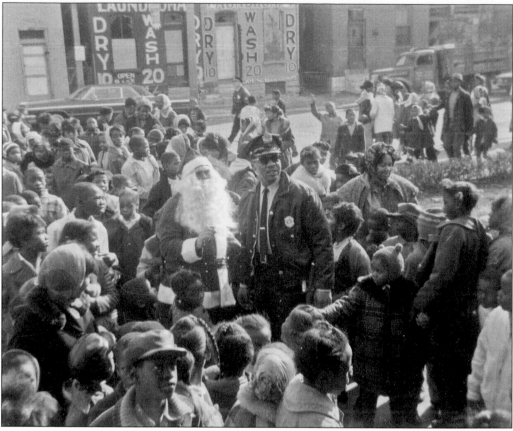

Santa even had a police escort. (Both, MHS.)

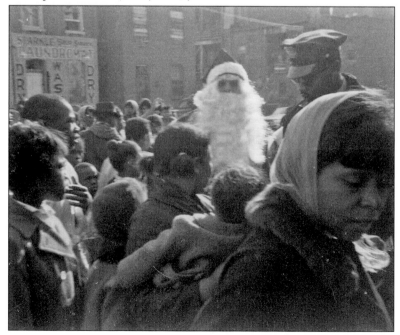

Santa had hardly left when the next day, December 18, around 11:00 p.m., two explosions—one in an 11th-floor apartment and another in a 10th-floor laundry room at 2330 Cass Avenue—injured 17-year-old Elijah McClennon and forced the evacuation of residents of the upper floors. A gas leak in the laundry below had ignited in Charlene Hampton's apartment when her son lit the stove. Hampton had reported smelling gas at 4:00 p.m., but the leak went undetected. By early 1967, many of the design time bombs were going off. Garbage chutes that were too small and too inconvenient led to piles of trash in the hallways and at the bottom of stairs, which in turn led to a burned-out furnace. (Right, MHS; below, PD.)

Doors that had
been removed from
buildings, like the one
at 2250 Cass Avenue
where Beverly Jones
(left) lived, were not
replaced for months.
People like Helen
Floyd (below, center),
one of the many
heroines of Pruitt-
Igoe, and Eugene
Porter (right), both
officers of the Pruitt-
Igoe Neighborhood
Corporation, met
with Mayor A.J.
Cervantes at city
hall to repeat
their requests for
improvements and
the appointment of
a project resident as
a Housing Authority
commissioner.
Tenants threatened
a rent strike.
(Both, PD.)

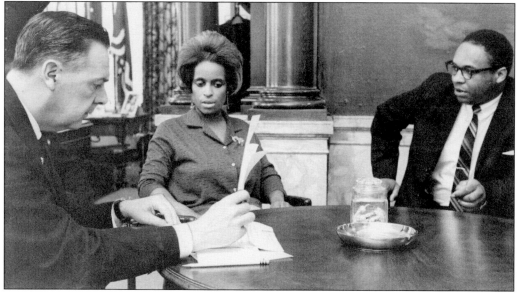

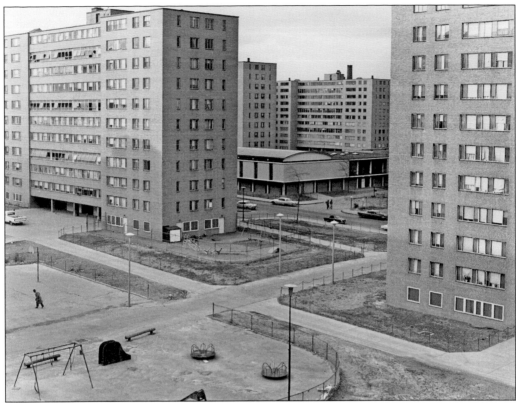

By February 1967, Pruitt-Igoe looked nearly abandoned, although it was not empty. It was entering another period in which the upward and downward forces seemed to be locked in combat. Below, Helen Floyd is looking at some of the bricks from the laundry room explosion. (Both, AR.)

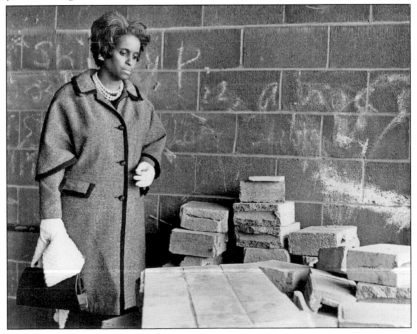

Typical of the dichotomy that was Pruitt-Igoe are these photographs taken only three months apart (in January 1967 and April 1967)—ones showing residents who are lacking hot water and heat, the others from an article about the "Proud Residents of Pruitt-Igoe," featuring something of a tour of well-decorated apartments. "It may come as a surprise to St. Louisans who own their own homes or rent apartments in more fashionable neighborhoods," the article said, "to learn that many tenants of the public housing project are as house proud as they. For people with limited incomes and unlimited aspirations, it takes more effort and greater ingenuity to attain the desired results." (Both, PD.)

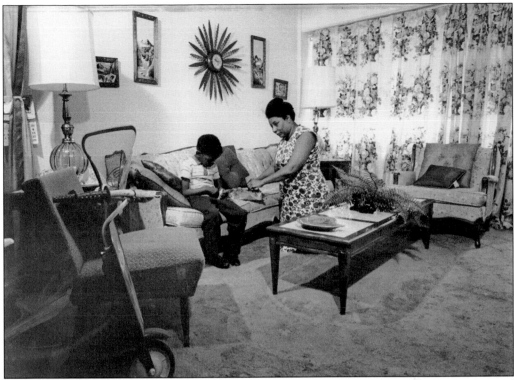

The April 1967 article also featured photographs of Sarah Wallace and her son Anthony (pictured above), in apartment 513 at 2311 Biddle Street, and Etta Mae McCowan (pictured below), in apartment 113 at 2330 Cass Avenue. "I like it here," said Cherry Jackson. "It's just about the nicest place we've ever lived." Cherry Jackson's daughter Lola, who lived at 2347 O'Fallon Street, said that most of the serious problems were caused by nonresidents who wandered into the project because there were so many public areas. Etta McCowan would continue to be active during the final days of Pruitt-Igoe, still trying to save it. (Both, PD.)

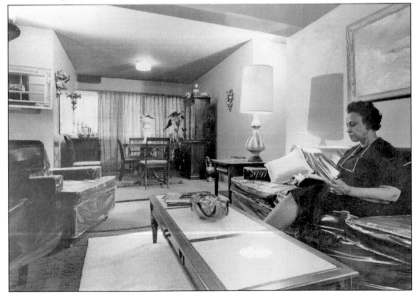

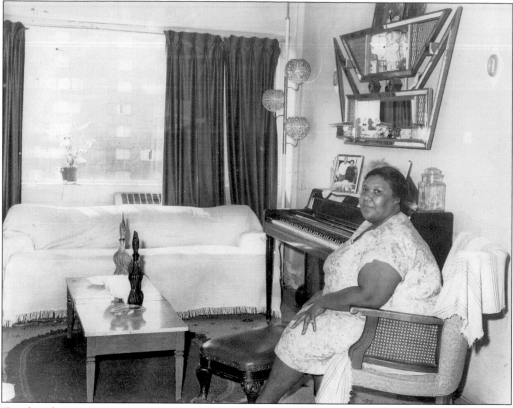

"It takes decent tenants to make decent housing," said Ella Taylor, who "raised" 24 children from her apartment in the Pruitt-Igoe housing project, in February 1967. "There are many advantages to living here," said Melissa Mitchell, "but no one ever seems to notice them." Meanwhile, below, in May 1967, Mr. Taylor found himself trying to offer encouragement and support to a youngster playing ball in a courtyard with a wall of broken-out windows as a backdrop. (Above, ML; below, AR.)

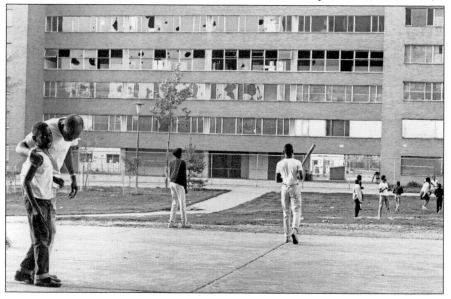

There was some recreation available for the older kids in the DeSoto Center, and there was even a tennis court set up in a parking lot in June 1967. (Both, MHS.)

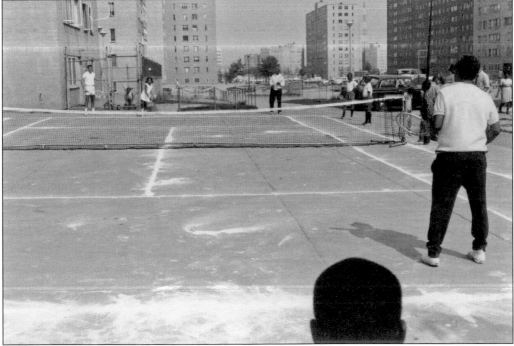

Also in June 1967, there was gardening and tree planting around Pruitt-Igoe, at Twenty-third Street and Carr. (Both, MHS.)

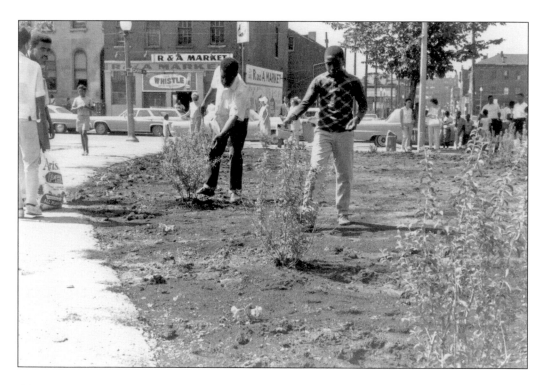

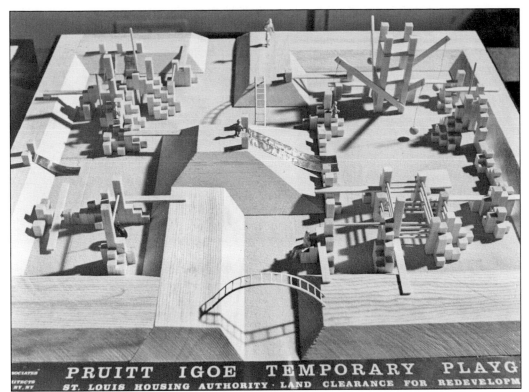

PRUITT IGOE TEMPORARY PLAYG
ST. LOUIS HOUSING AUTHORITY · LAND CLEARANCE FOR REDEVELOPM

The need for safe play areas for younger kids remained acute. In 1967, SLHA ordered the summer installation of six playgrounds as part of a $350,000 recreational program for the housing project. The playgrounds, of wood that could be dismantled and precast concrete forms, were designed by M. Paul Friedberg, who had created similar structures for a playground in New York City. In the photograph below, Friedberg is wearing a "Make Pruitt-Igoe #1" button. With him is Phillip Thigpen, manager of Pruitt-Igoe. But disagreements about what was most important continued to fester. John Wolf, chief of maintenance and engineering for SLHA, said, "Every time I asked for more help, they hired another planner, a dreamer." (Above, PD; below, MHS.)

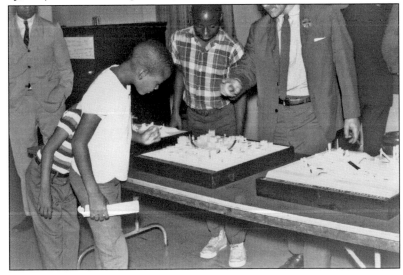

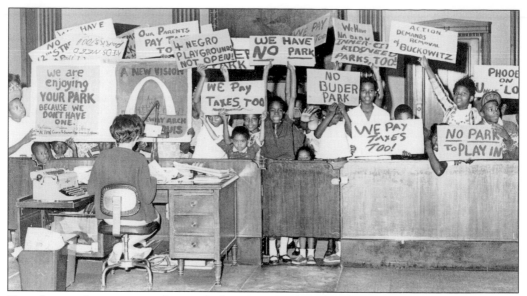

To make sure that concerns about safe play areas were heard and promises kept, on July 13, 1967, the civil rights group ACTION brought the kids' complaints right to the mayor's office—keeping their feet to the fire, so to speak. The children of Pruitt-Igoe found themselves at the center of many of the problems—and solutions—of the projects. Once a month, the children, led by adult residents, joined in a clean-up campaign of the buildings. About 700 children participated. The Progressive Men's Club was also organized to give male leadership to the many fatherless boys in the project. Aid to Dependent Children (ADC) policies were forcing men to abandon their families. (Above, ML; below, PD.)

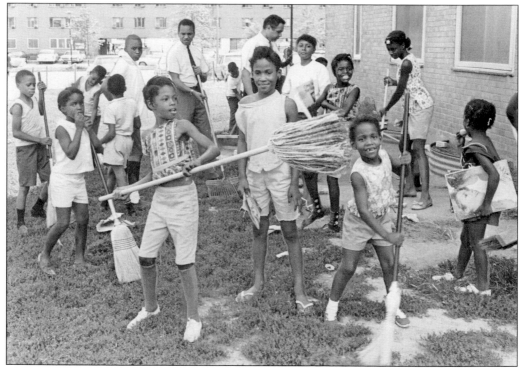

Also in July 1967, race riots broke out in Newark, New Jersey, and Detroit, Michigan. In Pruitt-Igoe, problems like sewage and sudsy water backing up into apartments were ongoing. There was one custodian for each 11-story building, including its public areas. "The people running this organization today are sitting in an ivory tower," said John Wolf, chief of maintenance and engineering for SLHA. "The back orders for repairs go back months." His crew included one plumber, one carpenter, one welder, one plasterer, one electrician, and one glazier—for 2,761 units. Margaret Pinkus, of the Ethical Society, and the Pruitt-Igoe Tenant Council sponsored a book sale (below) at the Community Center. Books, which sold for 5¢ to 10¢, had been collected by children of Ethical Society families in University City, Clayton, and other western suburbs. (Right, ML; below, PD.)

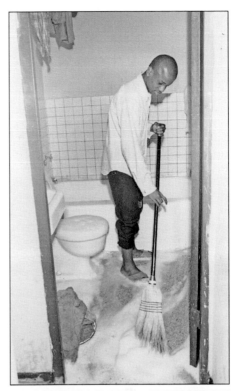

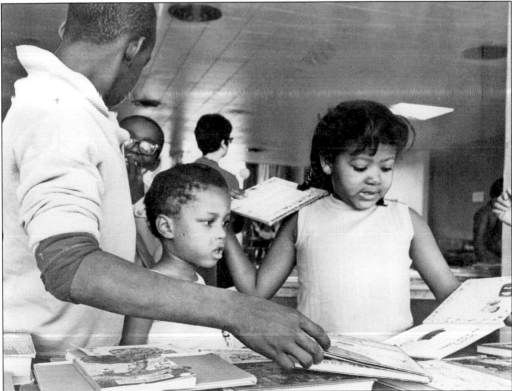

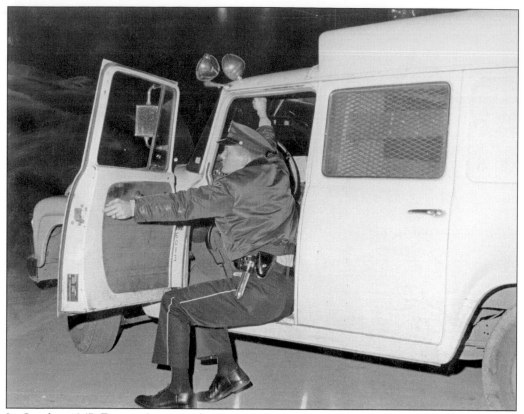

In October 1967, Eugene Sunnen, chairman of the Ethical Society public affairs committee in charge of the book show and sale at Pruitt-Igoe, observed, "We must develop a mutual involvement, if we are to get anything done." Drug dealers and snipers were by now occupying some of the upper floors of the increasingly vacant buildings. The Saturday night after Thanksgiving, Homer Shanks, a security guard at Pruitt-Igoe, was seriously injured by a sniper. Sunday night, police, including patrolman Larry Disbennett (pictured above), were at Pruitt-Igoe, shining spotlights on the buildings in an attempt to locate and arrest the sniper. (Both, PD.)

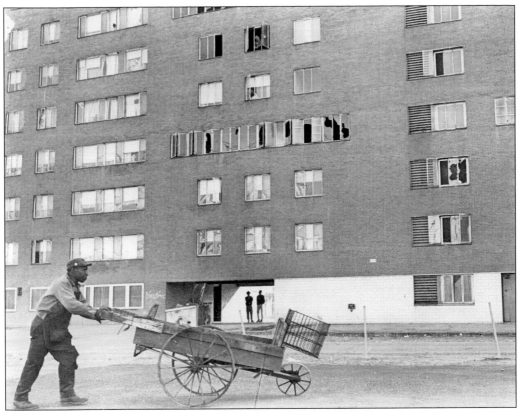

In February 1968, odds-and-ends trash collectors appeared in the housing development, pushing their carts just as they had in the old DeSoto-Carr neighborhood before Pruitt-Igoe went up. According to project manager Elgin Russell, junkies in search of money to support their habit went on a rampage, even tearing the copper sheeting from building roofs in hopes of selling it to scrap dealers. So when it rained, apartments leaked. Meanwhile, also in February 1968, children began using the free-form wooden playgrounds that had been installed recently. Said one tenant, "It seems they just want some grownup to watch them." (Both, PD.)

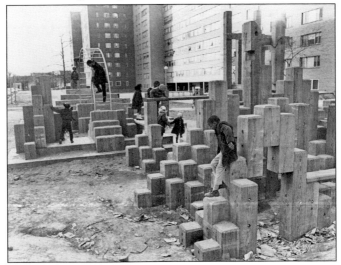

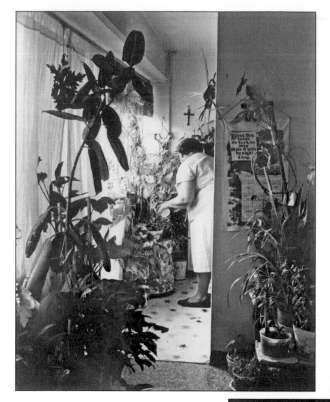

Many of the tenants were deeply religious and decorated their homes accordingly; to many outsiders, though, Pruitt-Igoe was shorthand for violence and crime, "the breeding ground for terror and sin," wrote one newspaper. On April 4, Martin Luther King Jr. was assassinated. Looking for a target for their anger and frustration, hundreds of people from Pruitt-Igoe came across Cass Avenue to Keller's Supermarket chanting, "We want Keller!" A Molotov cocktail caught the building on fire, with Keller in the back. Police called Reverend Davis of Grace Baptist. Reverend Davis arrived and got Keller out and into his car. Keller drove off, and the people stormed the grocery store, taking orange juice, diapers, and meat. (Both, ML.)

The friction between decent tenants and others continued. As part of the larger network of services, Father Shocklee, in April 1968, began Block Partnerships with other churches, such as Holy Redeemer Catholic Church in Webster Groves, St. Louis County. Other activities enlisted volunteers from the region and children in Pruitt-Igoe—like the painting project with five-year-old Fred Carson and volunteer Mark Digiacomo on April 27, 1968. The next day, a local paper ran a feature titled "The Separate World of Pruitt-Igoe: How an Impossible Dream for a High-Rise Public Housing Project Turned into a Ghastly Nightmare." (Right, ML; below AR.)

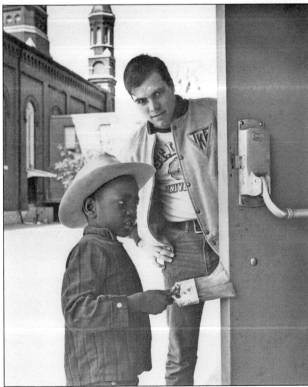

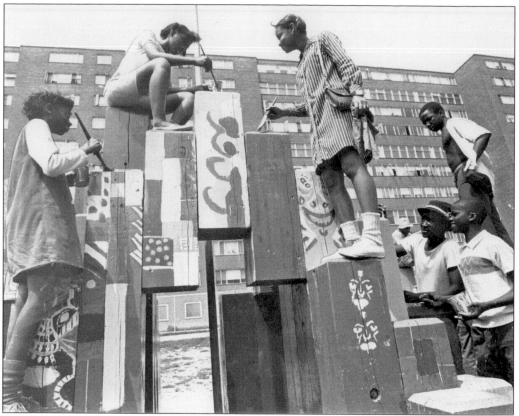

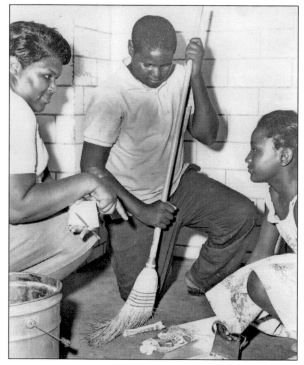

The wood and concrete playgrounds might have been functional, but the kids clearly thought they could use a little sprucing up. On June 6, some of the kids, as a school art project, painted the playgrounds with African tribal motifs. The paint was donated by SLHA. Children were constantly enlisted by their elders in the effort to keep Pruitt-Igoe livable. At left, Rachel Johnson shows Glenn Brown, 12, and Debra Brown, 9, how to clean a landing at Pruitt-Igoe. (Above, PD; left, ML.)

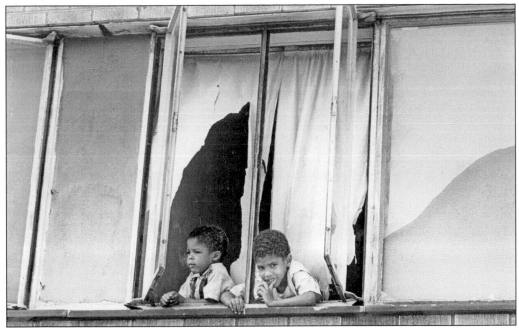

Jesse Jackson visited Pruitt-Igoe in 1968. So did J.A. Baer II (pictured below pulling the wagon), president of Stix, Baer & Fuller. At 2:00 p.m. on July 11 at Twenty-second and O'Fallon Streets, a Portable Play Street was donated by Baer: "a complete playground package, designed for movability from one area to another and for nighttime storage, [including] such equipment as volley and basketballs, golfing and bowling games, a merry-go-round, tractors, wagons and bicycles." The Human Development Corporation's Pruitt-Igoe Gateway Center also provided recreation, including field trips, for over 1,500 kids daily—and even that was not enough. Funding was insufficient for a program big enough to include all the kids who wanted to participate, so inevitably some were left out. (Both, PD.)

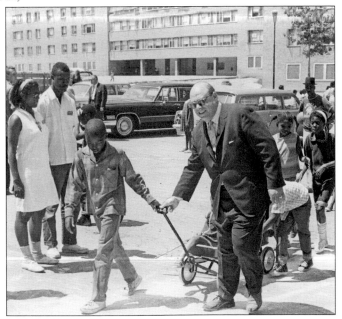

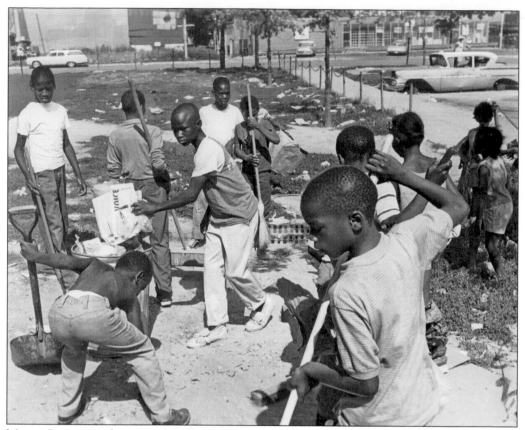

Mayor Cervantes threatened to fire project managers who did not keep the premises clean. Responded Big Bill Cobb, who brought outdoor music and dance to the kids weekly: "Hire, don't fire! Hire the kids around here. They can use the money and the project needs pride for what it can do on its own." Pictured here at 2429 Biddle Street, one of the kids' weekly clean-ups in July was delayed, said Eugene Elliott Sr., president of the building's tenant council, "because somebody stole some of our cleaning equipment." The August 1, 1968, Urban Development Act required local Housing Authorities to provide tenants adequate services and lower rent, but neither the federal government nor the state provided funding to do so. Below, on August 9, kids went "swimming" when the sewer could not take its water and flooded the playground. (Above, PD; below, ML.)

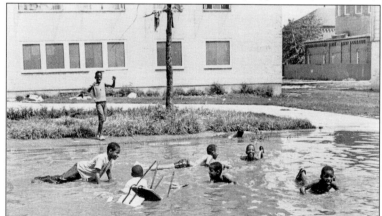

Some of the buildings, like the one at 2440 Cass Avenue where Mr. and Mrs. John Anderson lived, were redesigned especially for the elderly and for small families (masons built cinder block walls across some doorways to divide larger apartments into two smaller ones) as part of an effort to change Pruitt-Igoe into a series of individual neighborhoods. On August 4, 1968, James Bell, manager of Pruitt-Igoe, crowned Hilda Downs queen at a benefit contest to raise money for a new recreation room. And about 100 members of the Pruitt-Igoe Senior Citizens group, including Will Wilburn, 85 (left), and Sadie Calvin, 61 (right), attended the annual Thanksgiving luncheon. (Right, ML; below, PD.)

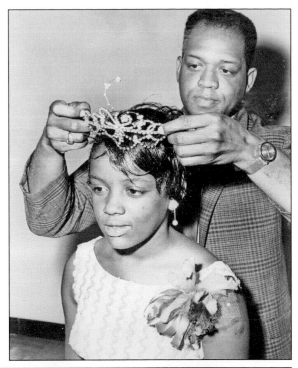

Margaret Pinkus, who had led the Ethical Society book event, died on September 26. Less than four months later, Frankie Raglin (above, left), the first person to move into Pruitt back in 1954 and a librarian, dedicated the new 1,500-volume Margaret Pinkus Library in the Pruitt-Igoe Community Center. Pinkus's husband, Lothar (above, right), attended. Margaret Pinkus, who also helped organize integrated field trips for the kids, had envisioned a study room for children and tutors, as a supplement to the Crunden Library down the street. The Ethical Society donated books, and the residents of Pruitt-Igoe were asked for their suggestions. Classifications included Afro-American, science, social studies, philosophy, and encyclopedias. Titles included *Black Profiles, Tell It Like It Is, Negro Protest, Black Power, Slavery, Manchild in the Promised Land,* and books about the civil rights movement. The library was open from 4:30 to 8:00 p.m., Monday through Friday. (Both, PD.)

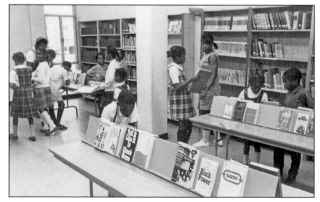

Three

NOT TOO COSTLY A MISTAKE

On February 10, Hazel Gibson, director of HUD's Relocation Division, wrote, "The people will not accept Pruitt-Igoe as a relocation source, and we should be able to understand why. . . . Since July there were six murders, and robberies are not counted anymore, especially on 'Mother's day,' the day the ADC [welfare] checks arrive." Prof. Gordon Misner found that, during 1969, police received 5,185 calls from Pruitt-Igoe for help. (ML.)

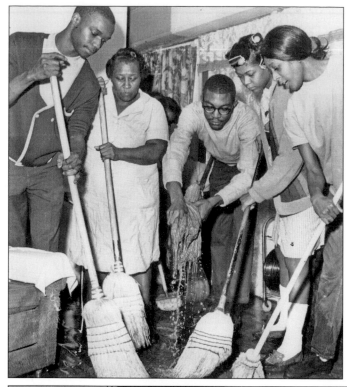

By 1969, Pruitt-Igoe was at 57 percent occupancy. Flooding was becoming a frequent event, but friends helped each other, such as Mitchell Ervin, Lula Anderson, Kenneth Duckworth, Daphne Anderson, and Luemer Anderson, seen here sweeping water from Mamie Ervin's apartment. The frequent leaks and flooding damaged the belongings of the residents, like Belzora Hicks, in her wheelchair, holding an overcoat that was soaked the night before when water flooded her apartment in January. In February 1969, a citywide public housing rent strike began; Pruitt-Igoe joined the strike in April. The Urban League Neighborhood Station closed in 1969. (Both, ML.)

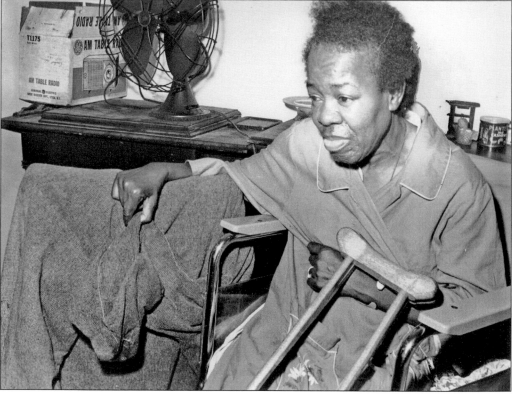

Guards like Sylvester Allen, with his pistol and two-way radio, were called in to watch over elevator repairmen like Wiley Johnson and B.C. Boyle. Repairmen had refused to repair elevators in Pruitt-Igoe without armed guards. As a result, elevator service had been out for much of a week. It was not just the repairmen who wanted protection. Utility meter readers estimated power usage rather than requiring technicians to go into the basements to read the meters. And on October 16, a group of about 30 Pruitt-Igoe residents showed up at police headquarters demanding that Chief of Police Curtis Brostron expand protection at Pruitt-Igoe. In October, the rent strike ended. (Above, ML; below, PD.)

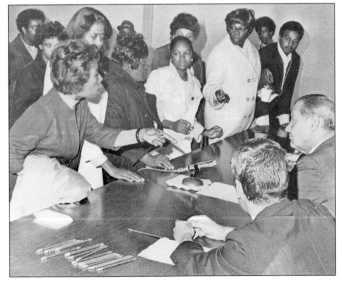

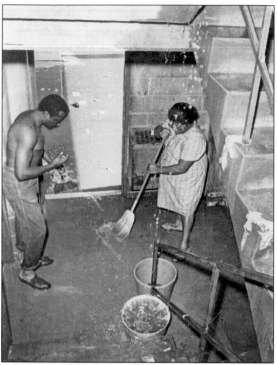

Fifty-five apartments at 2350 Biddle Street were flooded on November 8, 1969, when water ran down the stairs from an upper floor where a fire hose fixture had been removed. Residents said it was the fifth or sixth deluge they had had within the last year—usually because vandals would try to remove plumbing fixtures from unoccupied units. People also complained that the vandals broke out windows. The city began employing foot patrolmen, like Officer James Strantz (pictured below), as part of the effort to combat crime. Some neighborhood men also volunteered to walk the beat with the newly assigned officers. (Both, PD.)

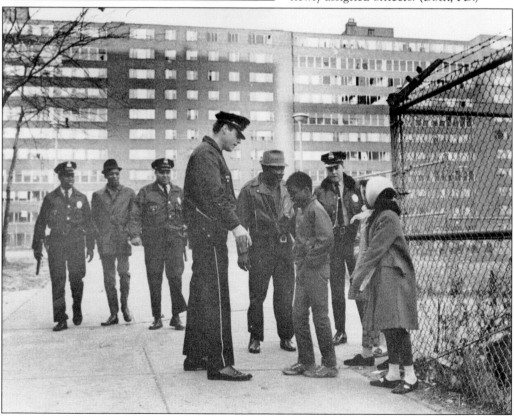

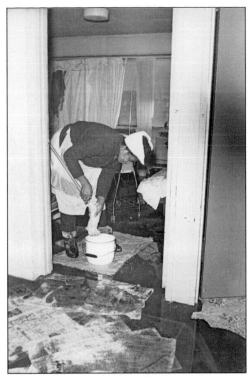

On Sunday, January 10, 1970, broken water pipes left more than 10,000 public housing residents across the city without heat, electricity, and water and drove some 200 people from their homes in freezing weather. People like Essie Troupe, at 2431 Dickson Street, used her gas oven to provide heat while she mopped up the water. Officials blamed the breakdown on vandalism: broken windows allowed inside pipes to freeze and break, spewing water into halls and stairwells and blowing out electrical transformers. The year before, in his confrontation with John Wolf, Irv Dagen, executive director of SLHA, had said, "Sure, broken windows are a problem, but the Housing Authority doesn't break them. They are replaced as soon as possible." (Both, PD.)

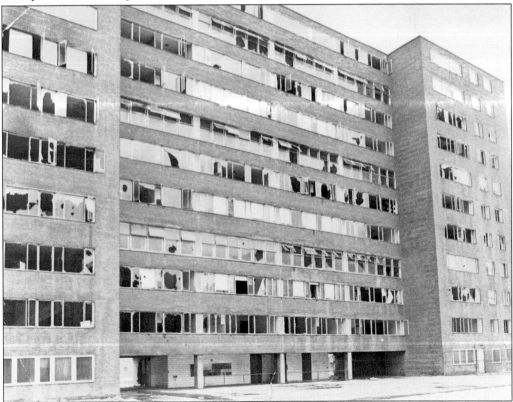

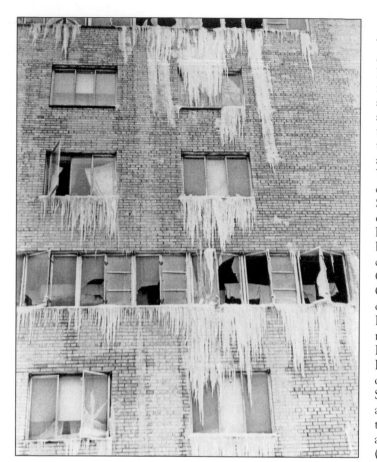

The Red Cross set up emergency headquarters. Elgin Russell, project manager for Pruitt-Igoe, said, "The stairwells were so iced up that we had to tie ropes around our waists to prevent us from slipping and falling down the stairs." William Schawacker, director of housing for SLHA, called it "a real emergency. We've never had anything to this extent before." Arthur Kennedy, director of the Model Cities Program, and Clyde Cahill, general manager of the St. Louis Human Development Corporation, met with tenants at Pruitt-Igoe. Said William Decatur, coordinator of social services for SLHA, "The people . . . are too busy [just] trying to exist. . . . These are angry, frustrated people." (Left, ML; below, PD.)

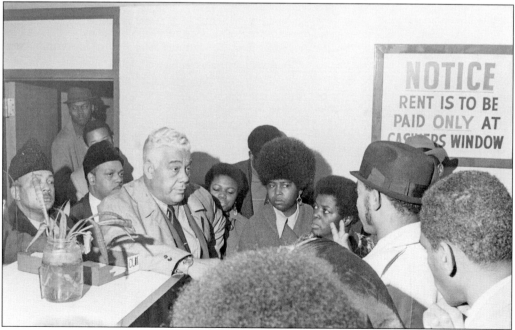

At 2311 Division Street, Nadine Eiland's sons Martin, 1, and Derrick, 11, stayed warm by the gas stove. Said one young ADC mother to a reporter, "All you people do is come down here and meddle in our lives so you can get stories and master's degrees and write some damn book. It may do you some good, but what good does it do us? We still get busted pipes and flooded apartments. We still get raped, robbed, murdered. You write to live and I struggle to live. Hell." (Both, PD.)

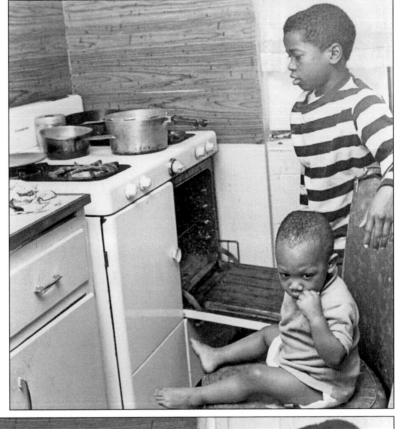

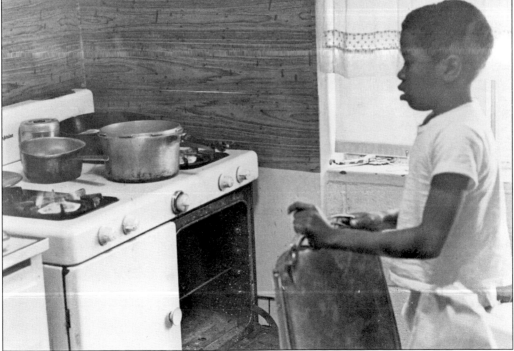

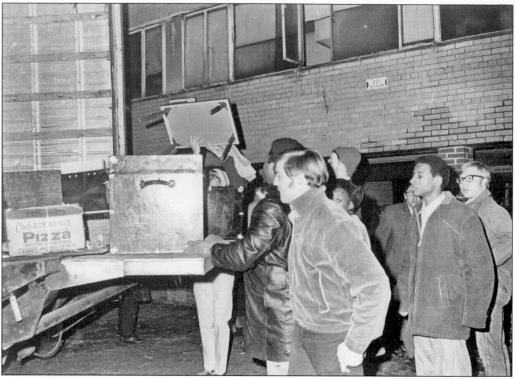

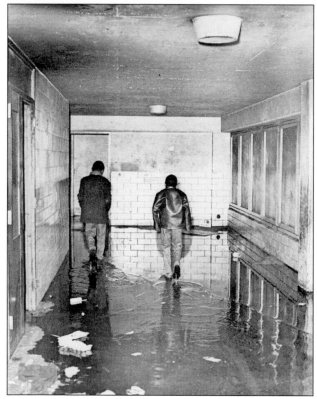

The worst flooding at Pruitt-Igoe was at 2311 Dickson Street, where Nadine Eiland and Ella Mae Durham lived, which had to be completely evacuated. Volunteers came to help, as seen above. The building at 2431 Dickson Street, where Essie Troupe lived, suffered heavy flooding—even on the seventh floor, where these two young men are walking (left). People in the apartments without electricity did the best they could to stay warm. The Red Cross provided food for about 250 persons who were unable to prepare food due to water damage and electrical outages. (Both, PD.)

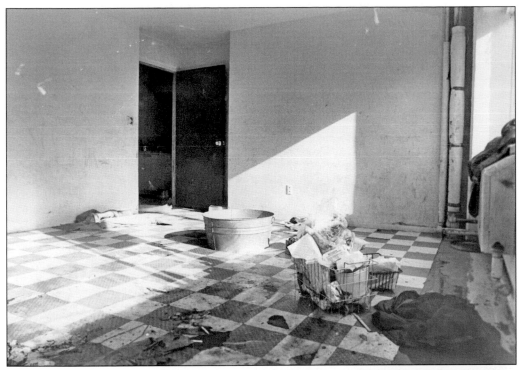

In the aftermath of the flooding, apartments like Ella Mae Durham's were all but uninhabitable. The water had loosened and buckled the floor tiles. Containers of spoiled meat and vegetables lay about the kitchen. In addition to volunteering to help with evacuation, people donated supplies and clothing to replace ruined items. Pruitt School had tables full of donated items like shoes, blankets, clothing, and food. It was also at this time that the Pruitt-Igoe baseball team was awarded their trophy at the Mathews-Dickey Boys Club benefit dinner. (Both, PD.)

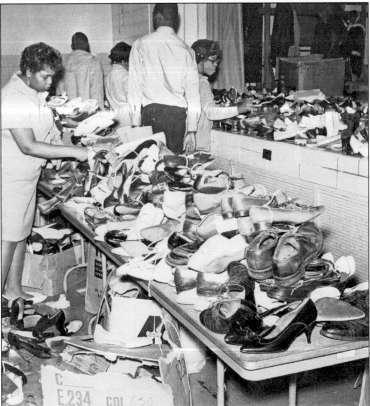

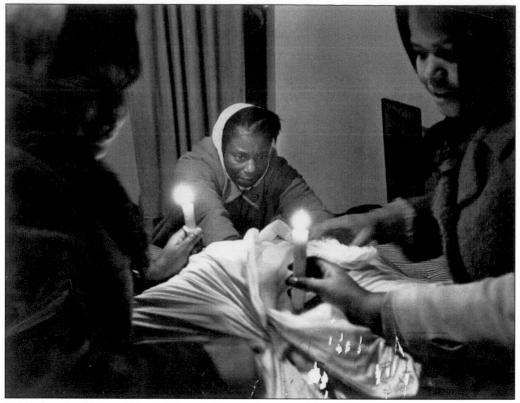

With the electricity still off, Johnnie Mae Jackson and her friends had to use candlelight to evacuate her apartment. By June 1970, Pruitt-Igoe was at just over 1/3 occupancy, down by almost half since January 1969. "Pruitt-Igoe is in trouble," said Helen Floyd. "If we don't [come] together," said Elmer Hammond, president of the Pruitt-Igoe Neighborhood Corporation, "this will be it." Said one civic leader later that year, "Out in the suburbs they are hardly aware of Pruitt-Igoe and environs. Unless you count the rash of political statements promising to crack down on crime and disorder that are flooding television." The Civic Alliance hired an architect to study renovating or demolishing the empty buildings. Willie Taylor, a member of the Black Liberators, said, "They have finished experimenting with rats and now it is our turn." (Above, PD; below, AR.)

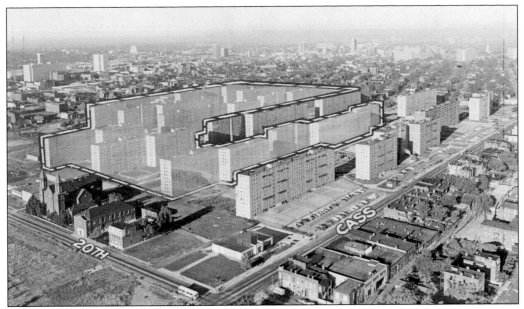

SLHA had announced in early September that 16 buildings would be closed, citing financial deficits and the fact that "many have not been paying back rents run up during the strike." Children like Zachary Marsh, at 2311 Biddle Street, were some of the only occupants in the vacant apartments—except the drug dealers, snipers, and the vandals who were stripping the apartments and selling the fixtures to local junkmen. Some people, though, like Geneva Clark, were living in apartments that had recently been redeveloped and did not want to be moved to a worse building. Said Ernestine Jackson, "They may have to bring in soldiers to get us out of here." Ruby Meyers said, "If they cut off my lights, water supply and heat next month, as they have threatened . . . I am going to stay here and freeze." (Both, PD.)

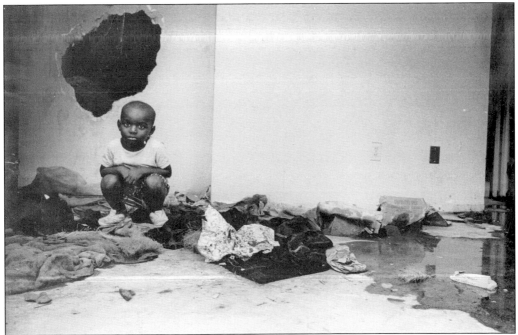

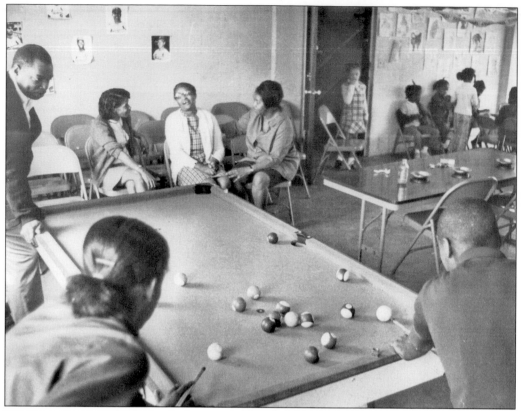

"It was like building a battleship that would not float," said SLHA director Tom Costello. "The damn thing sank. . . . Pruitt-Igoe is a cancer within a cancer." But other people remember the craft rooms; the upstairs Friday nights where there were artists, karaoke "before there was the word," people spinning records, and Lois Houston singing; and the "crooks and the good folks" all there together. At least one St. Louis Model City program was still in operation: Marcia Prater worked at the Pruitt-Igoe Community Center, at 2107 Cass Avenue, where she was a resident health agent. The real question," said a former tenant, "is not what is America going to do about Pruitt-Igoe. The real question is what is America going to do about its poor people?" (Above, ML; left, PD.)

Four

SEARCHING FOR KIM GAINES

"Unless we can solve the problem of internal order, it will be senseless to attempt any physical improvements," said SLHA director Tom Costello. "Without personal security, the social and economic problems are insoluble." Volunteer guards and police foot patrols had helped, but residents still felt unsafe, and vandalism was costing thousands of dollars a day. Women in particular were complaining about violence in the buildings. (ML.)

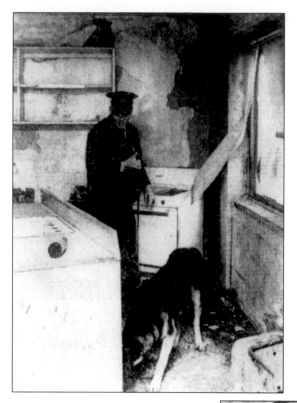

Anthony Dent, formerly of the Black Liberators, had organized volunteer security forces earlier in the year. On Monday, December 7, he was working with 50 young resident men hired as security guards. It was their first day and their first assignment: search the buildings and underground utility tunnels for Kim Gaines. On Sunday, Patricia Perkins, at 2429 Biddle Street, had sent her eight-year-old daughter to the store for margarine. On Tuesday, her shoe was found. Later that day, her body was found by patrolman Floyd Pendleton and security guard Melvin Jackson in a third-floor bathroom, the margarine under her body. She had been murdered. William Ditz, assistant manager, said, "We weld the doors shut, but it doesn't do any good. The thieves go through the walls, and then the children go in to play." (Left, PD; below, ML.)

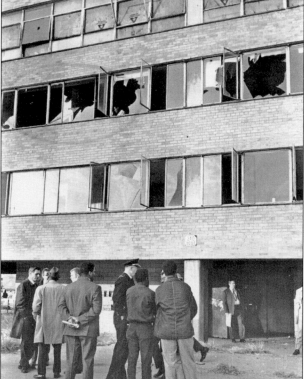

Kim Gaines's funeral was at night, in keeping with the black custom started when relatives could not leave their daily work to attend such affairs. Over 500 persons attended the service at Morning Star Missionary Baptist Church, at 2614 Dickson Street. One girl told of a teenage suspect. People demanded that the buildings be razed. Reverend A.L. Pryor told Kim's mother, "Love your children, do the best you can for them, and don't blame yourself for [her] death." In the morning, the family returned and took the body to Washington Park Cemetery for burial. SLHA discussed having armed guards patrol Pruitt-Igoe and covering the first three floors of vacant buildings with iron plates. A sketch of the suspect ran in the papers. A local newspaper reporter wrote, "Unless the situation is dramatically remedied now, tragedy will continue to stalk Pruitt-Igoe." (Both, PD.)

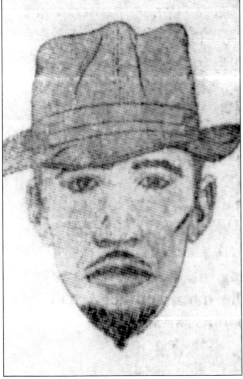

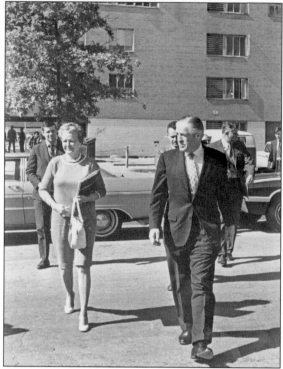

Pruitt would close; the remaining people were moved into several Igoe buildings along Cass Avenue. Redevelopment plans were priced at $50 million, on top of the $57 million already spent. "What a disaster!" said SLHA director Tom Costello. When challenged about the costs and all the mistakes that had already been made, Elmer Smith, the St. Louis area director of HUD, said that, compared to the Apollo space mission, "that's not too costly a mistake." The Civic Alliance for Housing proposed replacing Pruitt-Igoe with four villages of garden apartments and townhouses and service shops. When George Romney, President Nixon's head of HUD, visited Pruitt-Igoe on May 14, 1971, with Missouri representative Leonor K. Sullivan, he told Costello, "You've obviously made progress here." Costello said, "We have made progress, but we have problems." (Both, PD.)

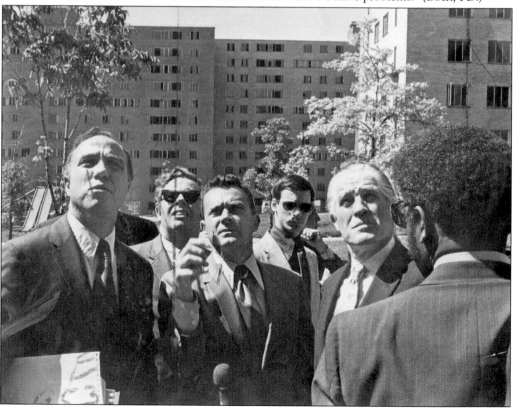

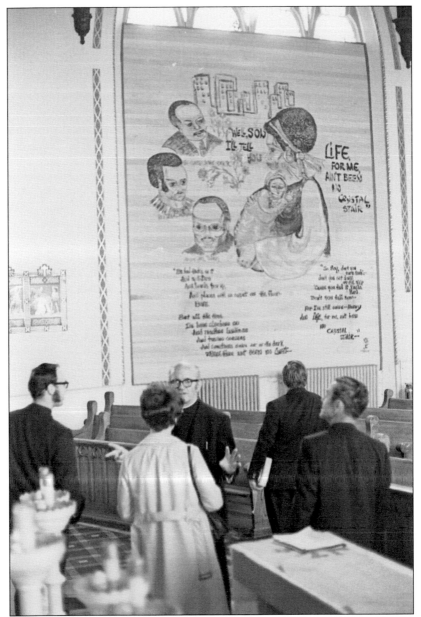

In June 1971, St. Leo's, having closed due to westward migration, reopened, hoping to become a national shrine of the Black Madonna. Children had knocked out most of the windows at the church with rocks. The cost of replacing the windows was exorbitant, so Sister Alma Zacharias set up a scaffold, shooed the pigeons, and painted the boarded-up windows with images of Dr. Martin Luther King Jr., Cleveland mayor Carl Stokes, and Jesse Jackson, as well as a mother-to-son poem by Langston Hughes: "Well, son, I'll tell you: / Life for me ain't been no crystal stair. / It's had tacks in it, / And splinters, / And boards torn up, . . . But all the time / I'se been a-climbin' on." Said Father Shocklee, "It epitomizes the agony of the Biafran mother as she watched her child starve to death. Many poor mothers in the inner city have felt the same way and Mary herself must have felt the same way when she had to take her child and flee to Egypt for safety's sake." They began planning a Black Madonna Festival for September. (AR.)

On Wednesday, July 14, Kathy McClellan, nine years old, was found murdered in a ninth-floor stairwell at 2420 Cass Avenue in the redeveloped Cass Plaza part of Pruitt-Igoe. The area had patrol guards. She was found by Rachel McClelland, 78, when she left a friend's apartment and walked up the steps about 1:30 p.m. Kathy, who lived at 2410 Cass Avenue in apartment 1006, would have been in fourth grade at Pruitt School in the fall. Homicide detectives arrested a 33-year-old man on information that he had offered firecrackers to kids and attempted to molest children in the area. "I saw little Kathy an hour before we found her body," said Marlene Harden, below. Eunice McClellan, Kathy's mother, who had lived in Pruitt-Igoe for 14 years, said, "I'm going to leave now. The first chance I get, I'm leaving this place." (Left, PD; below, ML.)

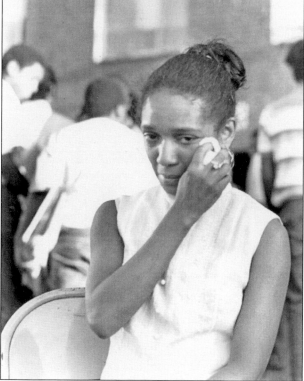

About 200 persons attended a rally that Friday sponsored by Project Concern in front of 2310 Cass Avenue. Elmer Hammond said he blamed George Romney, director of HUD, and Rep. Leonor Sullivan. "They do not care," he said. "Believe me, they do not care. They walk through here and look at two or three buildings then leave. Then Leonor Sullivan says people here don't know how to live . . . How the hell does she know?" Betty Thompson said, "The ironic thing about it is that Representative Leonor Sullivan toured one of the buildings and told me that the building was an example of what other parts of Pruitt-Igoe should look like. The building she was talking about was the same one where Kathy McClellan was found dead." Mr. and Mrs. Howard Petty and their 18-month-old daughter Vanteen also attended the rally. (Both, PD.)

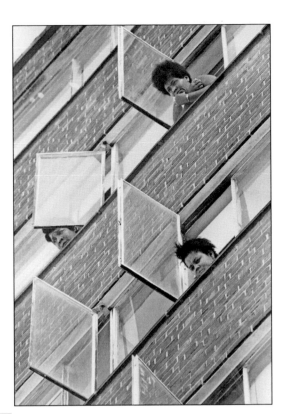

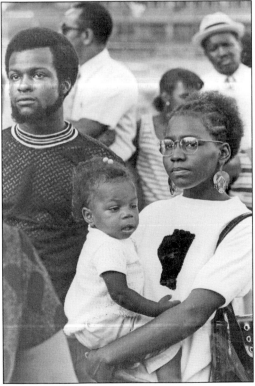

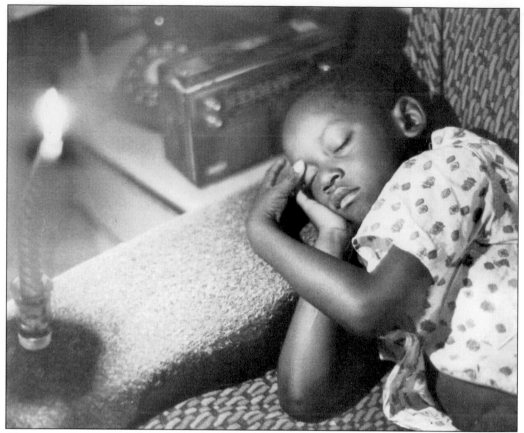

Above, another power failure in three Pruitt-Igoe buildings left Antwon Thurman, at 2433 Dickson Street, going to sleep by candlelight and listening to a battery-operated radio. Across Cass Avenue, Reverend Davis, with the help of neighborhood children, his own children, and area ministers, cleaned the soot and ash from the burned-out cinder block building that once housed Keller's Supermarket. Keller never returned after 1968. A new front was added, and in 1971 the building became the new location of Grace Baptist Church, replacing the two-story house-church next door. Reverend Davis paid Keller $100 a month rent; later on, Keller's heirs simply deeded the church to Davis, who became a fixture in the neighborhood in his green and white Volkswagen van, picking up parishioners and starting a food pantry. (Above, PD; below, SLU.)

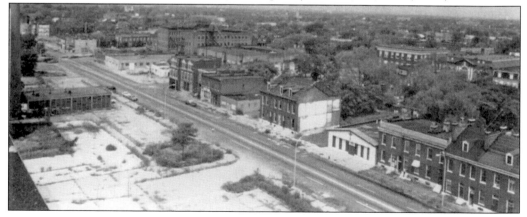

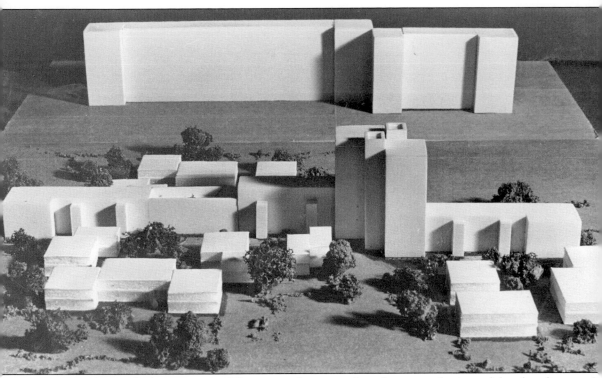

Reverend Davis had competition. Thieves, working out of two houses to the east of the church, were knocking off trucks coming down Cass Avenue and selling stolen televisions in Pruitt-Igoe. "Fats" (a.k.a. "Fat") Woods and Earl Williams Jr. would become the most notorious black gangsters in St. Louis. The Igoe building at 2310 Cass, directly across the street from the church, was nicknamed "Dodge City." Walking down Cass could be like running a gauntlet. Some people armed themselves before entering Pruitt-Igoe to visit friends or family. Several firms were contracted by the city to look into redesigning Pruitt-Igoe: Skidmore, Owings & Merrill (Chicago); Harland Bartholomew and Associates (St. Louis), authors of the 1947 plan that declared DeSoto-Carr "extremely obsolete"; and Urban Development and Design Corporation, a black-owned firm doing inner-city renewal in Detroit. Skidmore, Owings & Merrill (SOM) issued an action report. In October 1971, George Romney, director of HUD, ordered a tear down and start over for the housing development. From October 1971 to June 1972, the firms set up offices in Pruitt-Igoe. Proposals included cutting off top floors to lower the buildings and removing the center sections, leaving just the adjoining end towers where structures met. Echoing Yamasaki's other project that was under construction, the World Trade Center, the designers dubbed these the "Twin Towers." The group took their plans to Washington. (PD.)

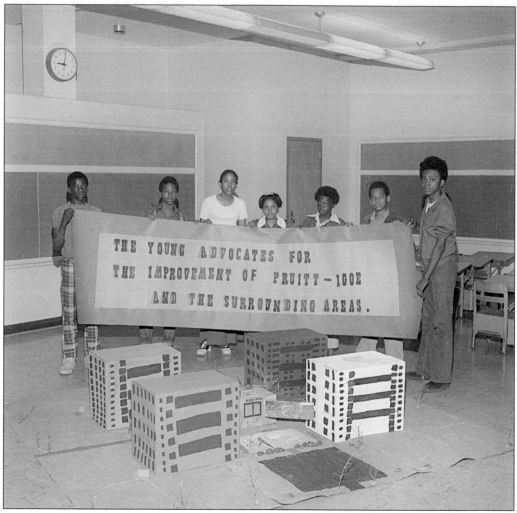

Another idea, involving the Missouri Botanical Garden, was to cover and landscape the upcoming demolition rubble into playgrounds or parks and convert the first-floor apartments into basements. Roller skating, splash pools, rock concerts . . . there were seven variations of the plans. While the group made presentations in Washington, Etta McCowan asked about 150 tenants to fast as a sign of hope for renewal. "That's how bad they want to stay," said Ruby Russell, "and how much they want something good to develop. Most people don't realize that Pruitt-Igoe is our home. We don't want to move out west." Land Clearance Authority planner David Hrysko had called the out-migration west "something else." Mayoral aide A.J. Wilson said large developments like Pruitt-Igoe "would trigger violence and friction even if the inhabitants were upper-class, college-educated whites." Meanwhile, students at Pruitt School—The Young Advocates for the Improvement of Pruitt-Igoe and the Surrounding Areas—had their own plan, which looked remarkably like the SOM plan. Neither the professional plan nor the student plan would get built. (PS.)

Five

A LITTLE BIT OF EXPLOSIVES WITH A LOT OF GRAVITY

Mark Loizeaux, of Controlled Demolition, said, "I think of a building as a person. I have to find out all I can about it, searching in every corner for any secrets it might have, and then prepare my plan of attack. That building is fighting me." Loizeaux's father, John Loizeaux, president of Controlled Demolition, described the process as "mixing a little bit of explosives with a lot of gravity." (PD.)

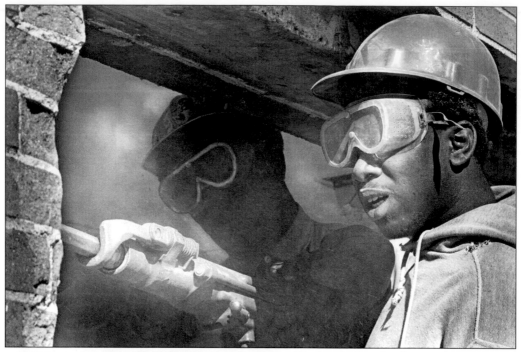

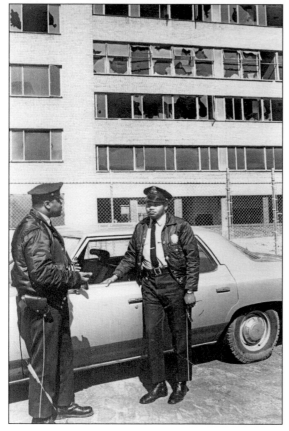

For days before the first implosion, workmen like George Henderson (above, left) and George Davenport (above, right), both of Laborers International Union Local No. 53, drilled holes for dynamite. On March 16, the day of the first implosion, officers Donald Glenn and Richard Brown, seen at left, were assigned a new duty/service—to guard persons making deliveries to Pruitt-Igoe. Security personnel would also escort deliverymen to the proper apartment. A small mini-blast in the morning was a trial run for what would happen that afternoon. The morning blast left nothing but the steel reinforcing rods from the concrete pillars. New York businessman Walter Hook said, "I was just thinking of all the years this thing was sitting here, and nobody would lift a finger." (Both, PD.)

The afternoon blast was supposed to take place shortly after 1:30 p.m., and helicopters full of photographers hovered overhead. But nothing happened. A little after 2:15 p.m., it was reported that the blasting machine had been taken to the airport by a Dore superintendent who had gone to the airport to pick up Arthur Dore, president of Dore Wrecking Company, which had the contract for the job. Dore had subcontracted the blasting to Controlled Demolition. But Arthur Dore's flight from Michigan had been delayed by bad weather. When Dore—and the blasting machine—arrived from the airport, the wires were rigged up and spectators watched the demolition man push the plunger. The western half of the building at 2207 O'Fallon Street came down. (Right, PD; below, BS.)

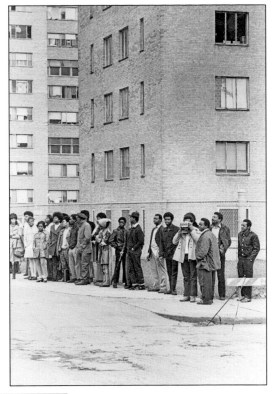

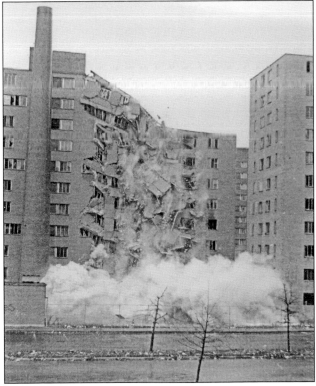

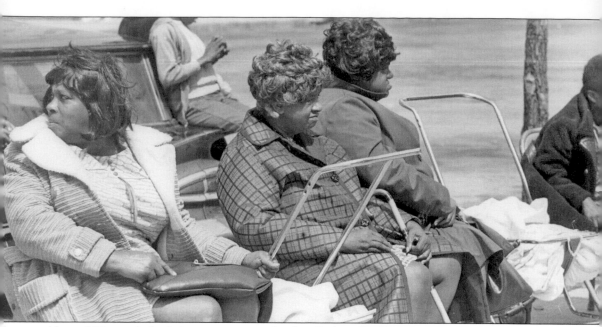

About 500 people had shown up to watch what Robert Duffe, executive assistant to Mayor Cervantes, called "the best show in town." Ninety-six dynamite charges had been placed. "I don't know if it can be done," Mark Loizeaux had said, but afterward he called the job "a perfect vertical severance. I don't think you could do a cleaner job if you cut it with a knife." After talking with St. Louis officials following the first blast, it was decided not to try the cutting-down project by explosives; the implosions would be purely for demolition. Someone else would clear the rubble later. Washington University architecture student Keith Fitzgerald, 21, had been at Pruitt-Igoe every day for three days so as not to miss the implosion. When it finally happened, he said, "Wow, what a heavy scene." (PD.)

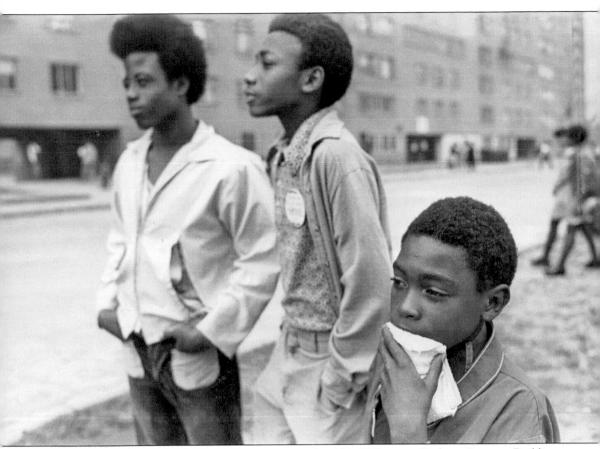

The second and most dramatic implosion came on April 21, 1972, across Dickson Street at Building C-15. Some folks hid; others got as close as they could. Photographers were stationed all over. Some of the local design team that had worked on the redevelopment plans had cameras on the ninth floor of the building across the street. One hundred and fifty-two holes had been drilled for sticks of dynamite in a long humped arc from the basement to the second floor (72 on the ground floor, 72 on the first floor, and 8 in the basement), timed to go off in sequence milliseconds apart, so the building would collapse down and in, not out. People waited and watched from their lawn chairs. Kids covered their faces with handkerchiefs. (PD.)

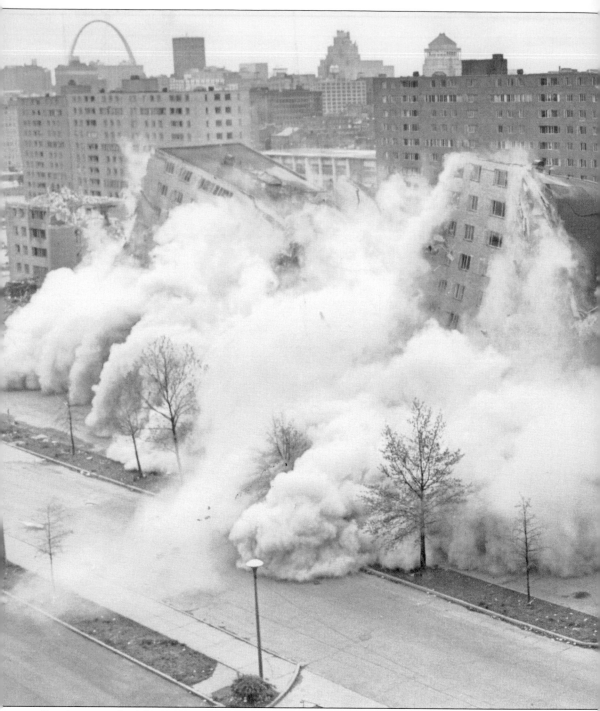

Residents watched from apartments. Engineers watched from vacant buildings. Students watched from the Pruitt School. Reverend Davis watched from in front of his church. "Fats" Woods and Earl Williams Jr. might well have been watching from Williams's Pruitt-Igoe apartment. That year, the *Evening Whirl* ran a rueful satire headlined "Vicelords T.J. Ruffin and 'Fats' Woods to Run for Mayor of City." In the story, "the two crime overlords had taken over the city" and Williams, "the

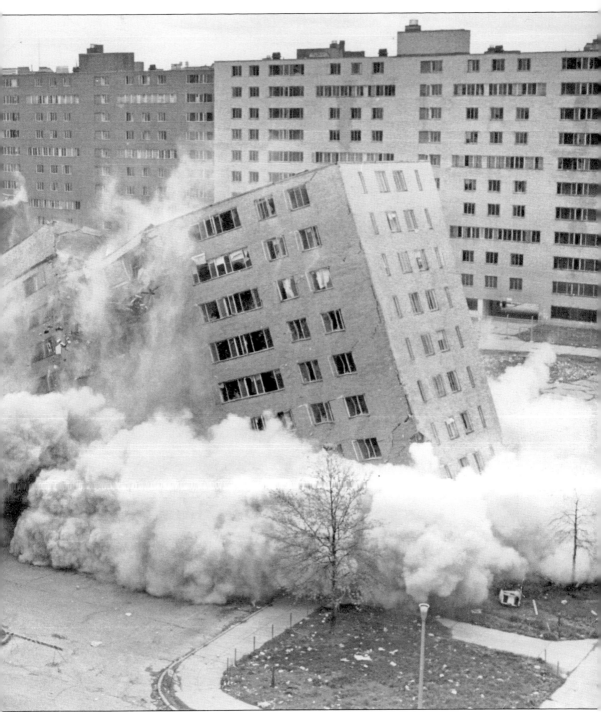

gang's lead assassin . . . had learned his trade with a high-caliber rifle as a Marine Corps sniper in Vietnam, but for his work stateside he preferred, a bit self-indulgently, sawed-off shotguns. . . . in order to reach him, and offer one's regards, it was necessary to pass through a platoon of armed sentinels. He had ensconced himself in the projects like a *nazir* in his tents." (PD.)

With another university grant to train 150 residents as unarmed security guards, to be chosen by the Tenant Advisory Board, the women on the board demanded that ladies be included. According to Administration of Justice program manager George Misner, the four women guards, including Loretta Turner (pictured at left), were the most reliable officers in the group. A few days after the second demolition, Burnice Askew, 16, of 2407 O'Fallon Street, walked into the security office around 6:00 p.m. with a five-inch-long blasting cap. An 11-year-old youth had tried to borrow a match to light one of the blasting caps. Several more caps and sticks of dynamite, including one that was fully primed with a blasting cap, were recovered by Det. Norman Klefisch (pictured below) and the Bomb and Arson Squad that Sunday. (Left, PD; below, ML.)

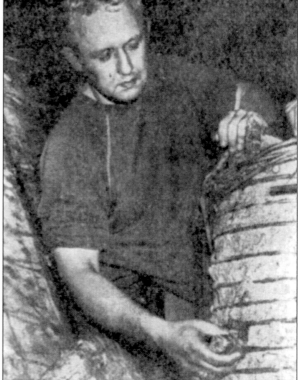

Six

A PERFECT
VERTICAL SEVERANCE

On June 2, 1972, HUD announced it would not approve the SOM plan as "the plan [didn't] make any sense." On June 9, 1972, there was one last implosion, but then HUD ruled out further demolition and confounded St. Louis leaders by tying Pruitt-Igoe redevelopment to a new convention center. Fr. James Hasse, of Chicago, completed a portrait for St. Leo's upcoming second Black Madonna Festival. (AR.)

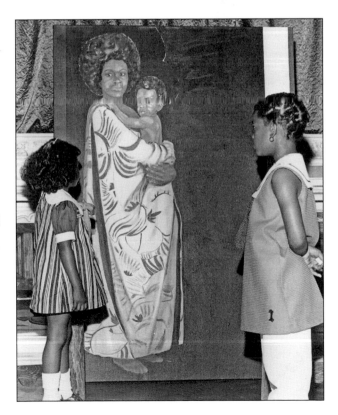

The second annual Black Madonna Festival at St. Leo's was held on September 17, 1972. An outdoor art exhibit complemented the unveiling of Father Hasse's portrait. Also in 1972, Father Shocklee disbanded his Bicentennial Corporation. The implosion rubble remained, all plans for parks and landscaping seemingly forgotten. Children walked past it on their way to school. Said Ruby Russell, "I've seen children playing on it. The security guards have been instructed to watch it, but there's no way to watch where kids are 24 hours a day. It's not safe." People felt it was causing rats. Gangs were cooking drugs up in the vacant buildings. Still, that same month, Ruth Thomas did a survey of 749 families; most of them said they wanted to remain in the area. (Left, AR; below, PD.)

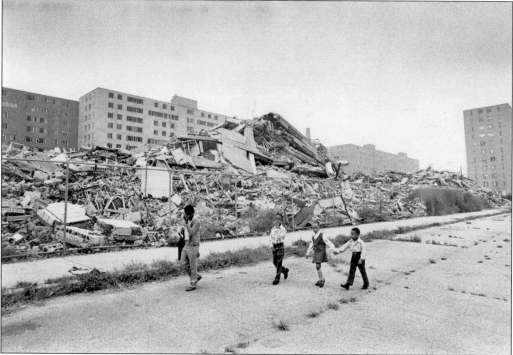

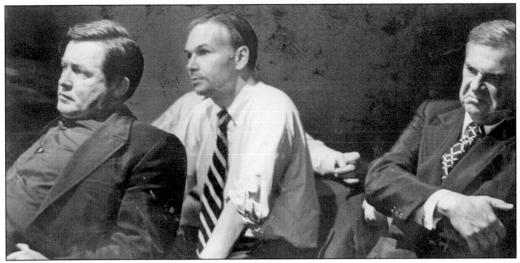

Mayor Cervantes (pictured above on the right) was not hearing much good news, from the federal government or locals. "We're simply overtaken by mice," Cecilia Brinker said. "They seem to come from everywhere since this stuff [the rubble] has been here." Rose Titsworth said, "You're not supposed to want a convention center to come up before you get housing for people . . . They're going to do with us what they did with the people in Mill Creek." On October 9, SLHA director Tom Costello and Rep. William Clay investigated a vacant building and found a rifle and heroin. On May 23, 1973, with only 587 occupied units, Costello proposed complete shutdown and relocation. Bessie Gatling (below left) and Viola Martin (below right), meeting in June at Carr-Lane School about the shutdown, did not look any happier than the mayor. On September 20, it was announced that Pruitt-Igoe would be demolished. The rubble would be hauled off in October. (Both, PD.)

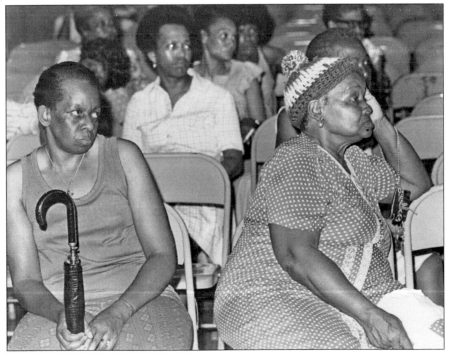

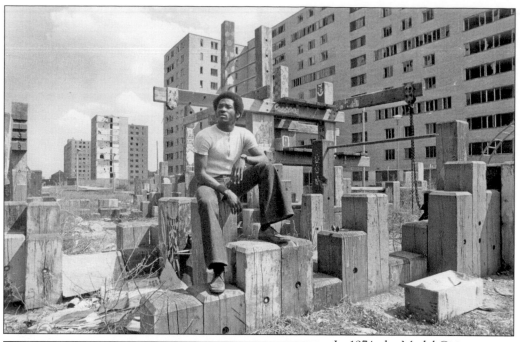

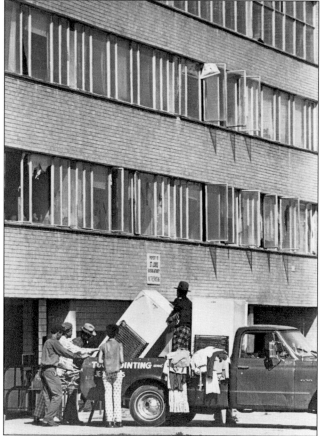

In 1974, the Model Cities Program ended. Among the last tenants leaving Pruitt-Igoe was Lillian Towns. Her son Billy Towns, a 20-year-old freshman at State Fair Community College, returned. In 1968, when he was 15 years old and living with his mother in Pruitt-Igoe, Billy was the subject of a film, released in 1969, titled *More Than One Thing*, by Washington University graduate student Steve Carver. On May 3, 1974, the last remaining families moved out of Pruitt-Igoe. Among the people leaving that last Friday were James Donlley (moving to Westminster), Charles Higgins (who brought his truck, moving to North Grand), Myrtle Cannon, and Charlesetta Dickerson. Most of the moving had been done by Friday evening—19 years, 6 months, and 22 days after Frankie Mae Raglin and her family first moved in. (Above, ML; left, PD.)

Myrtle Cannon loaded up Charles Higgins's truck. Charlesetta Dickerson said, "Everything they did was wrong. What did they do that was right?" Beatrice Jones, who lived there 10 years, said, "The adults were okay, they came and went and minded their own business. But not the kids; there were too many conflicts when they mixed together. . . . People have trouble everywhere, though—in Ladue, in River Roads—anywhere, it's all the same. Outsiders have a problem understanding what conditions here really are like, but insiders understand each other." Visible in the view below is another of the playgrounds like the one Billy Towns was sitting on, and a bit of the old neighborhood is still there peeking through in the upper right. (Both, PD.)

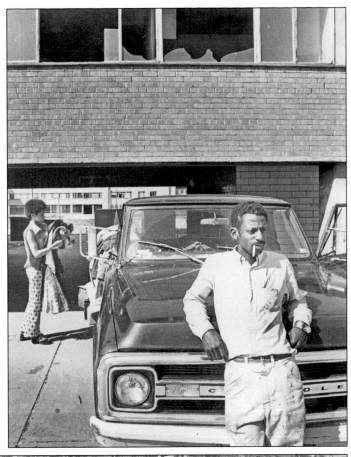

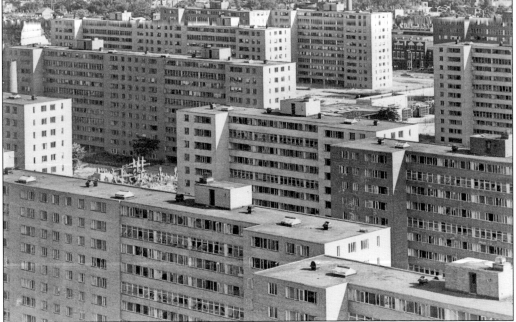

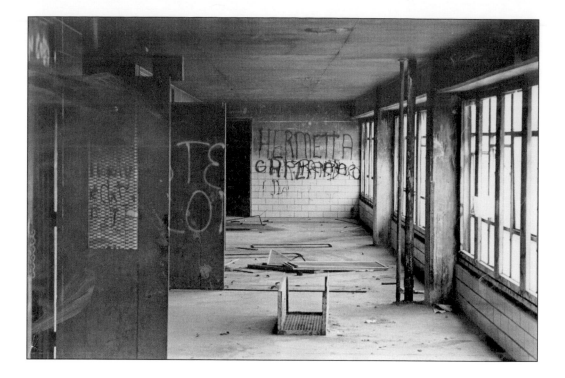

Article after article said "Pruitt-Igoe must be destroyed." Resident Helen Robinson said, "When I drive past now, I get a hurt feeling. When they blew up those buildings, I got a hurt feeling." Rachel Johnson said, "We worked hard in Pruitt-Igoe. We planted flowers and we waxed the floors. We loved it." Nettie Taylor said, "It was nice, it was really nice. It was a decent place to be in. We had trees and benches and garbage cans at the ends of the benches and we could sit outside at night. Women could sit outside . . . and nobody would bother them and things were pretty smooth for a few years." Someone wrote on a wall, "Elaine was here and now she's gone / she left her name to carry on. / By The Unknown." (Both, PD.)

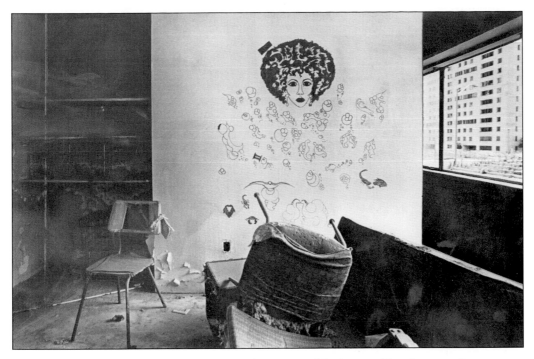

On February 6, 1975, Harold Antoine, general manager of the Human Development Corporation (HDC), wrote in the *St. Louis Argus*, "The highest and best use might be . . . letting them stand as a tourist attraction, . . . [as] mammoth monuments to Man's colossal failure to meet the needs of its most needy. [It made] many of the personalities hard, as if the concrete has infused the spirits of those who lived there. . . . As if by alchemy the heroines were replaced by . . . heroin." In July 1975, Al Lumpkins (standing), of the Office of Equal Opportunity, and two black groups—Gateway 2000 (a minority contracting group) and the St. Louis branch of the Missouri-Kansas Construction and Contractors Assistance Center—asked the city to delay the bidding on the demolition so some black firms could bid, too. (Both, PD.)

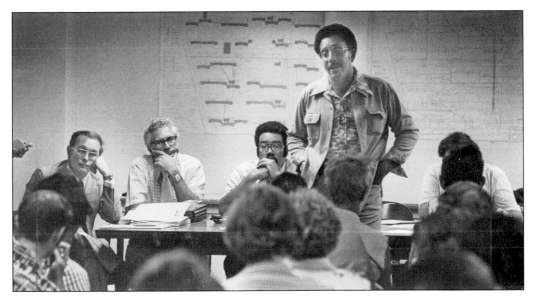

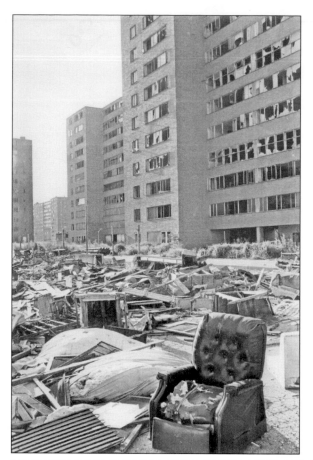

In September, SLHA awarded a contract to minority contractor Cleveland Wrecking Company from Cincinnati, Ohio. Tom Costello said, "We are doing everything we can to ensure minority involvement in the demolition." (Left, BS; below, PD.)

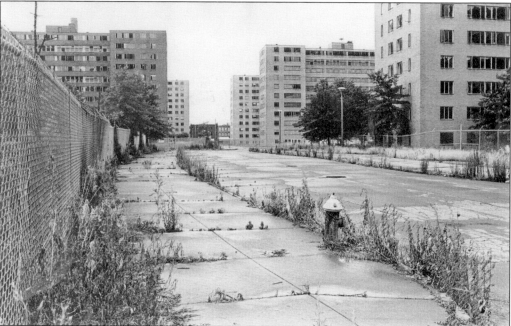

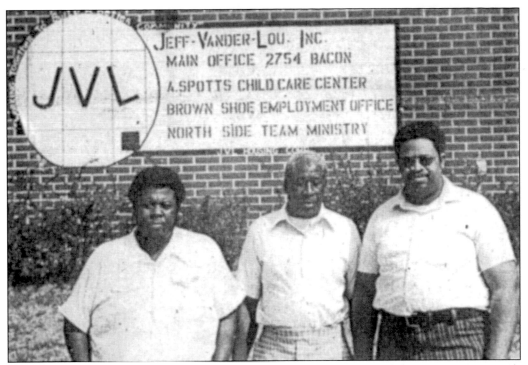

While others fled, Macler Shepard (center) and Jim Sporleder pursued their community work through Jeff-Vander-Lou, Inc. Shepard mused, "We just push our way into things and when they succeed they say it's a miracle so they won't have to fund anything like it again." In October 1975, Shepard and Sporleder designed a plan to save and reuse four Pruitt buildings at the southeast corner near Pruitt School and DeSoto Park as a defensible walled village. The city supported the plan; the federal government did not. Another plan surfaced. A November 16, 1975, letter to the editor read, "The *Post-Dispatch* recently ran several articles on the overcrowding of the City Jail. . . . The renovation of the Pruitt Igoe complex . . . is the solution to the overcrowding of the city jails. —Kenneth Deason, Arnold, Missouri." (Above, SLA; below, PD.)

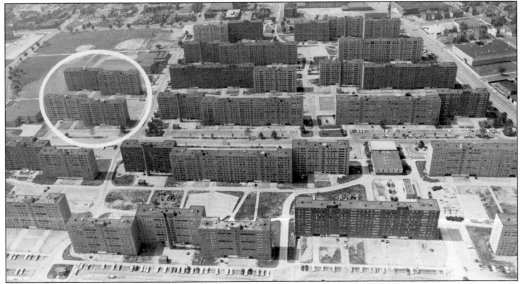

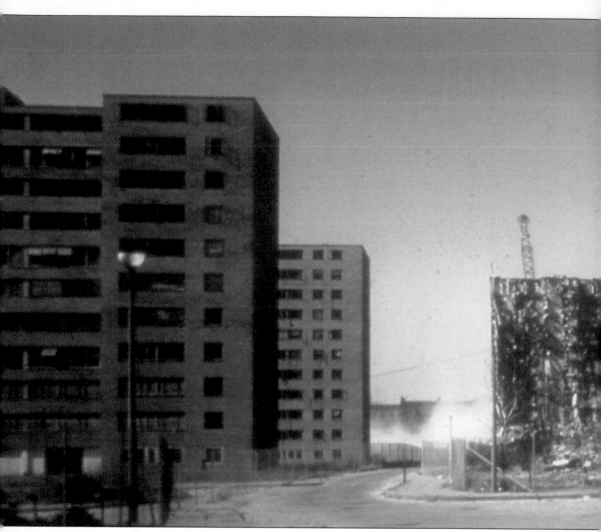

And the city within the city came down, not by implosion, but by wrecking ball and by hand. Macler Shepard had asked that the four buildings he hoped to save be torn down last, just in case. Nothing survived. The people who had lived in—and survived—Pruitt-Igoe eventually dispersed throughout the city and county. Many joined the general northern and western movement of black

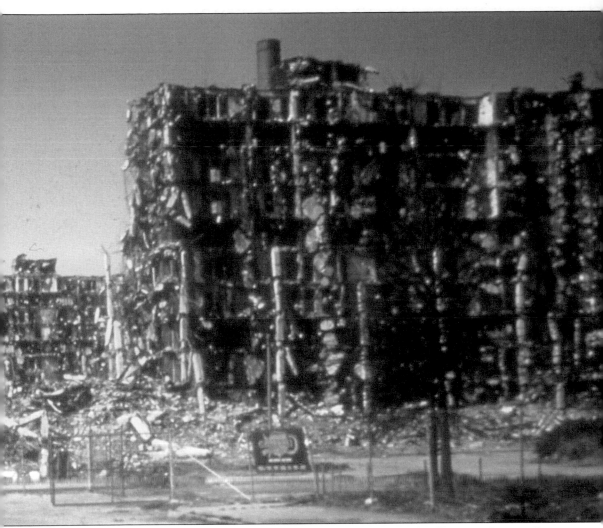

residents in the region. Others, like Ida Mobley, were able to stay nearby. She moved across Cass, to 2327 Mullanphy Street, just a block north of Grace Baptist. Annual Pruitt-Igoe reunions—large, joyous get-togethers—began almost immediately and are still going. (TT.)

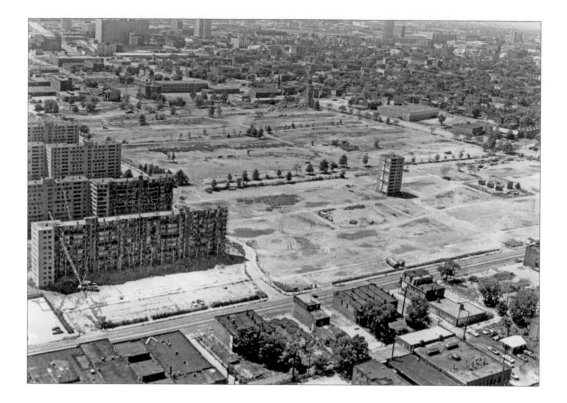

By 1976, all the remaining buildings but one (above and below) were demolished. A National Science Foundation grant was given to a team headed by Theodore Galambos, chairman of the Civil Engineering Department at Washington University in St. Louis, to do structural engineering tests to develop design criteria for earthquake-resistant buildings. The Community Center would go, too. The DeSoto Center lasted a few more years and then was also demolished. The Electric Station remained and, as of 2017, is still there. (Above, ML; below, PD.)

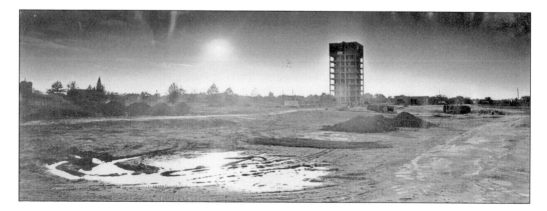

Seven

Behold the Tabernacle of God with Men

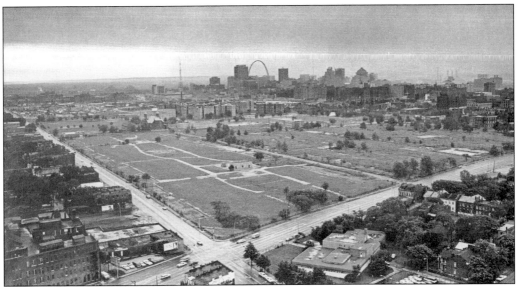

Plans came and went—fishing lakes, an urban village—but nothing was built. With time, a forest arose, along with strange outcroppings—a street light in the woods here, a fire hydrant beneath some brush there, and manhole covers and broken asphalt underfoot. People used the site for dumping, which some people mistook for the rubble of Pruitt-Igoe; it had been taken to a West County quarry. Wildlife moved in. (PD.)

In June 1990, Irv Logan Jr., the metropolitan conservation coordinator for the Missouri Department of Conservation, promoted the idea of turning the site into an urban preserve for nature and wildlife. The idea resurfaced again in the "Pruitt-Igoe Now" international design competition in 2012. While cutting some exploratory roads through the old development in late 2016, the remains of the old brick public barbecue pit at Jefferson and Cass Avenue that Jack Saunders had helped build were revealed—one of the later improvements to Pruitt-Igoe and, for several years, a hub of social life there. (Above, PD; below, BH.)

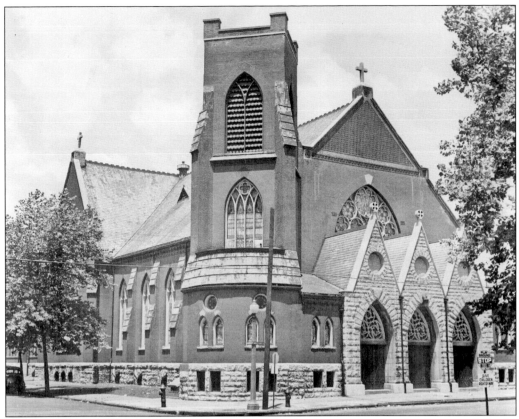

Parishioners continued to leave the neighborhood, and upkeep of the churches became difficult. Father Shocklee left St. Bridget's in 1976, as Pruitt-Igoe was coming down—the same year that Yamasaki's World Trade Center (the official "Twin Towers," which would meet their own fate on September 11, 2001) was completed. St. Leo's was demolished by the archdiocese in 1978, leaving behind only the cornerstone on a vacant lot at the corner of Mullanphy and Twenty-third Streets, inscribed, "Behold the Tabernacle of God with Men." Father Shocklee died in 2003. (Above, AR; below, BH.)

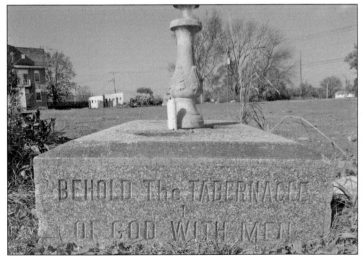

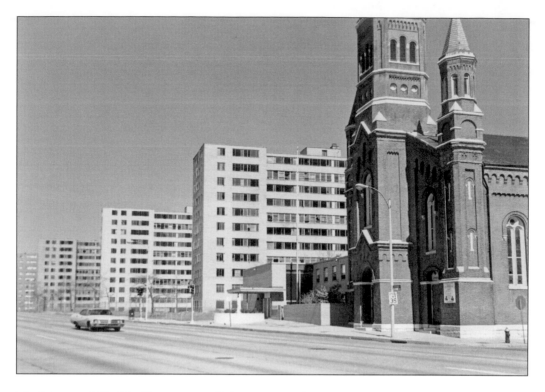

The Municipal Health Clinic eventually became—and remains—the fire department. After years of vacancy, Pruitt School reopened in 2015. For a period in the early 2000s, St. Bridget's was home to an Ethiopian Orthodox congregation. The building hung on, one of the five oldest churches in the city, until 2016, when it was demolished to make way for an expansion of the school next door. The demolition generated heated arguments about history, culture, preservation, and the entire review process. (Above, SHS; below, BH.)

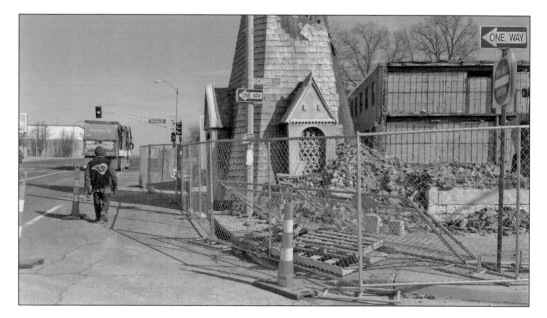

Along Cass Avenue, the original Crunden Library building was demolished in 2005. The second Crunden Library became the Church of the Living God; the book depository slot still works. The Pruitt-Igoe Neighborhood Station sat vacant for years. Eventually, the roof caved in, the doors and windows disappeared, and trees grew up inside. As of late 2016, it was slated for demolition, along with scores of other buildings—homes (including Ida Mobley's), businesses, and churches—for the relocation of the National Geospatial-Intelligence Agency (NGA). The area was declared blighted; eminent domain was invoked. In April 2017, the building was demolished. (Both, BH.)

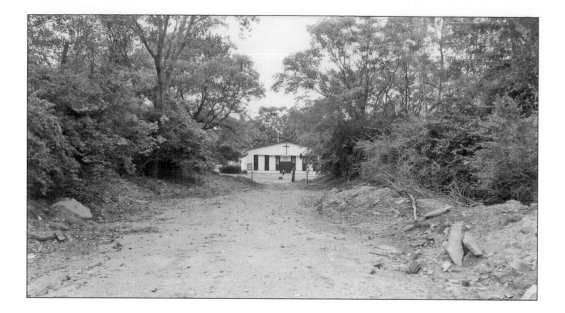

Also slated for demolition for the NGA relocation was Grace Baptist Church, "The Pearl of Cass Avenue." Reverend Davis turned 100 years old on Easter in 2015. He had watched the Pruitt-Igoe demolition from in front of his church. When a little girl said, "Rev. Davis, they're tearing us down," he told her, "Yes, and we'll be here when they build it back up again." On May 1, 2016, with eminent domain proceedings claiming the land, the doors of the church were officially shuttered. Reverend Davis died May 17, 2016, a month after his 101st birthday, still hoping to preserve his church. It was not to be. On May 18, 2017, the building was demolished, exposing charred timbers that still smelled of the 1968 fire. (Both, BH.)

Macler Shepard died in 2005. Father Kohler died in 2006. Tom Costello died in 2010. Father Heck died in 2015. Jim Sporleder died in 2016. A developer bought the Pruitt-Igoe site from the city in 2016. Dickson Street was opened up a bit by electric crews that fall, and other paths were cut through the woods, crisscrossing the site in the search for underground infrastructure. People reported seeing not just rabbits and owls, but also deer and red tail fox. Some have spoken of the strangely populated forest in the city as "the green cathedral." Sacred ground. The future awaits. So does the past. (EN.)

CAPTAIN WENDELL OLIVER PRUITT
HOMES

DWIGHT D. EISENHOWER
PRESIDENT

CHARLES E. SLUSSER ALBERT COLE
COMMISSIONER ADMINISTRATOR
PUBLIC HOUSING HOUSING AND HOME
ADMINISTRATION FINANCE AGENCY

RAYMOND R. TUCKER
MAYOR

BOARD OF COMMISSIONERS

ARTHUR A. BLUMEYER
CHAIRMAN

L. F. HAVEY T. A. JEFFERSON R. J. NOONAN
B. H. TUREEN J. P. TROUPE E. C. FARRELL
H. J. KUTZ REV. J. E. NANCE L. C. JUSTI

EXECUTIVE DIRECTORS
JOHN J. O'TOOLE CHARLES L. FARRIS

HELLMUTH, YAMASAKI & LEINWEBER ARCHITECTS
WM. C. E. BECKER STRUCTURAL ENGINEER
JOHN D. FALVEY MECHANICAL ENGINEER
HORNER & SHIFRIN UTILITY ENGINEERS
HARLAND BARTHOLOMEW & ASSOC. LANDSCAPE ARCH.
MILLSTONE CONSTRUCTION, INC.
GENERAL CONTRACTORS

The original plaques from Pruitt and Igoe were removed and saved. (BH.)

WILLIAM L. IGOE APARTMENTS

DWIGHT D. EISENHOWER
PRESIDENT

· · ·

CHARLES E. SLUSSER
COMMISSIONER
PUBLIC HOUSING
ADMINISTRATION

ALBERT COLE
ADMINISTRATOR
HOUSING AND HOME
FINANCE AGENCY

RAYMOND R. TUCKER
MAYOR

BOARD OF COMMISSIONERS

ARTHUR A. BLUMEYER
CHAIRMAN

H. J. KUTZ L. C. JUSTI

W. A. GEORGE T. A. JEFFERSON J. P. TROUPE

R. J. NOONAN REV. J. E. NANCE E. C. FARRELL

EXECUTIVE DIRECTORS
JOHN J. O'TOOLE CHARLES L. FARRIS

HELLMUTH, OBATA & KASSABAUM, INC. ARCHITECTS
WM. C. E. BECKER STRUCTURAL ENGINEER
JOHN D. FALVEY MECHANICAL ENGINEER
HORNER & SHIFRIN UTILITY ENGINEERS
HARLAND BARTHOLOMEW & ASSOC. LANDSCAPE ARCH.
MILLSTONE CONSTRUCTION, INC.
GENERAL CONTRACTORS

They are stored in an upstairs room at the St. Louis Housing Authority. (BH.)

DISCOVER THOUSANDS OF LOCAL HISTORY BOOKS FEATURING MILLIONS OF VINTAGE IMAGES

Arcadia Publishing, the leading local history publisher in the United States, is committed to making history accessible and meaningful through publishing books that celebrate and preserve the heritage of America's people and places.

Find more books like this at
www.arcadiapublishing.com

Search for your hometown history, your old stomping grounds, and even your favorite sports team.

Consistent with our mission to preserve history on a local level, this book was printed in South Carolina on American-made paper and manufactured entirely in the United States. Products carrying the accredited Forest Stewardship Council (FSC) label are printed on 100 percent FSC-certified paper.